ORIGAMI
FOR BUSY PEOPLE
27 Original On-the-Go Projects

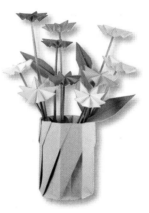

MARCIA JOY MILLER

TUTTLE Publishing

Tokyo | Rutland, Vermont | Singapore

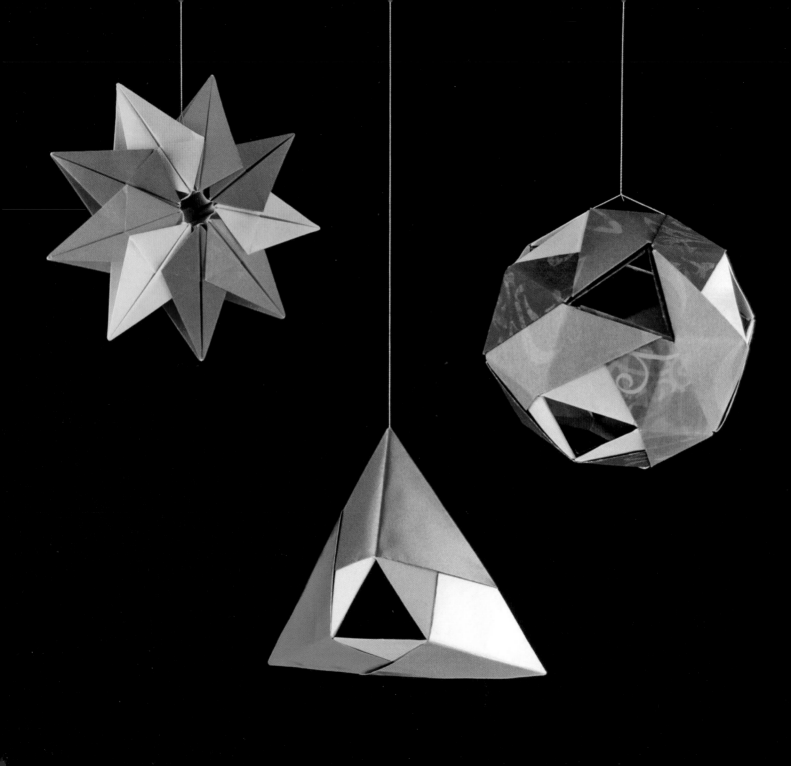

Contents

Discover Your Inner Folder: Working Origami into Your Busy Schedule

You're a busy person and it's not easy to find time for leisure activities. With work and family obligations, pursuing a new interest is often put on hold for "someday" no matter how appealing that interest may be. Well, "someday" is here. This book will make it possible for you to fit the exciting, fun-filled adventure of origami into your daily schedule. Simply choose the time slot that works for you—coffee break, lunchtime, or after work—and then fold amazing things from paper. You will create beautiful treasures for your home and delightful gifts for your family and friends.

This book makes learning origami a cinch for people on the go. It is a step-by-step guide written for beginners—although the intriguing projects will interest experienced origami enthusiasts as well. All of the projects are completed purely by folding and do not require the use of scissors or glue.

When I was four years old, to my delight I was introduced to origami. I was immediately fascinated and it soon became an avid interest for me. In later years, as my skills advanced, my focus widened to encompass the designing and teaching of origami. Many of my adult students told me how much they enjoyed origami and that they wished there was more time for it in their schedule. This concern and my desire to share my love for origami inspired me to write this book—which is tailored for busy people.

Enhance your folding experience by joining an origami society. A few such organizations are: OrigamiUSA, 15 West 77th Street, New York, NY 10024-5192, (212) 769-5635, http://www.origami-usa.org; The British Origami Society, 2a The Chestnuts, Countesthorpe, Leicester, UK LE8 5TL, http://www.britishorigami.info; Origami Sociëteit Nederland, Postbus 24054, 3502 MB Utrecht, The Netherlands, http://www.origami-osn.nl; and Centro Diffusione Origami, Casella postale 28, 27011 Belgioioso (PV), Italy, http://www.origami-cdo.it.

Now that you have a glimpse of the adventure that awaits you—let's begin.

—M.J.M.
Lawrenceville, New Jersey

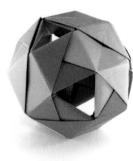

Getting Started

This book was designed with the busy person in mind. It is organized so that you can enjoy origami, even on a hectic schedule. Each of the chapters that follow includes projects that are geared to a particular span of free time that you have available in your day. For example, if you would like to make an origami creation during a short period of time, such as your coffee-break, refer to Chapter 2. For projects that you can fit into lunchtime, see Chapter 3. In Chapter 4, you will find projects that require a bit more time and are more appropriate for after work. If you are mainly interested in projects that take little time to complete, then in addition to Chapter 2, you will also be interested in Chapters 3 and 4. They include projects that have components that can be made during coffee breaks or lunch breaks—and then the completed creation may be assembled at a later time.

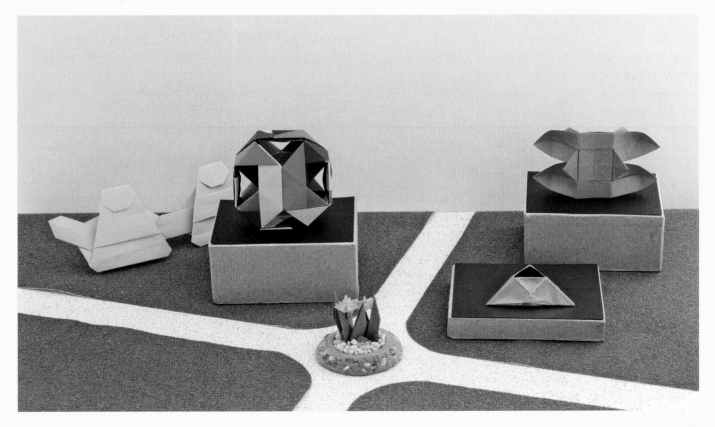

Each project is taught through step-by-step illustrated instructions that are simple to follow. Getting started on a project will be easy. The opening segment of the instructions for each project indicates what type of paper is required and which basic techniques you need to know. In addition, the instructions indicate the skill level required for the project. There are many beginner projects. If you are new to origami, these are the ones that you should start out with. After you complete several of them and feel comfortable with the beginner level, you will be ready for the intermediate projects.

Now, let's focus on this chapter which prepares you for the projects. It will describe the papers that are required, all of which are readily available. You will learn about the special terms and symbols that are used in the instructions for each of the projects. In addition, you will be given some folding tips and you will learn to read the diagrams. The last section of this chapter includes short exercises on basic techniques that can be practiced during coffee-breaks.

Throughout the book, you will find information and photographs that depict attractive ways for displaying your origami. Origami is a very creative activity. Soon you will find yourself experimenting with paper choices and ideas for showing off your creations. You may even surprise yourself and invent an origami design!

SUPPLIES

Choosing paper for each origami project will be simple and fun. The instructions specify which types of paper that you will need—all of which are easily obtained. For each project you will be able to use either paper that you have around the house or, for those models specified in the book, the included folding paper. All of these materials and a few options are described below.

Bond paper is the type of paper used in photocopy machines and computer printers. A variety may be found in stores that sell office supplies. This book will refer to 20 pound bond paper as "lightweight" and 24 pound as "medium weight." When at your local office supply store, be sure to also peek at the memo cube papers. They are conveniently packaged and suitable to use for some origami projects.

Origami paper is sold in packages of pre-cut squares. Most have a color or attractive pattern on one side and are white on the other. The sizes that will be most useful to you are six-inch and ten-inch although, in reality, these papers are a little smaller. Their exact measurements are fifteen centimeters and twenty-five centimeters respectively. Washi paper, also sold packaged, is softer and thicker than regular origami paper and has a fancier fabric-like appearance. Some origami creations, especially simple ones, can be folded and look lovely made from washi. Those that produce a movement or a noise generally do best with regular origami paper because of its ability to take crisp folds. Origami paper may be purchased at arts and crafts supply stores or from an origami supplier.

Folding paper, which is included in the back of the book for your convenience, may be used for twenty-one of the projects when indicated by the instructions. These papers are designated for certain specific projects and have patterns that complement the finished project. All of the projects that have designated folding paper may also be made from either origami paper or bond paper, as described by the paper requirements for each of those projects.

Ordinary paper that you have on hand, such as notebook paper or brown wrapping paper, will often work satisfactorily for origami. These papers may also be used in the practice exercises. Notebook paper can be an adequate substitute for origami paper when color is not important and is especially suited for easy projects. Brown wrapping paper, depending on its weight, can possibly be substituted for bond paper. Junk mail, some of which is printed on bond, is an economical and colorful alternative. Look around you for an endless supply of other free papers that you can experiment with such as brochures, discarded gift wrap, magazine covers, and old calendars. Not every sample of free paper will fold well, but you will have a good time testing them.

Aluminum foil is needed for one project in this book. What you have in your kitchen will work just fine.

Paper-backed foil is not required for any of the projects. It is, however, suitable for a few projects in the book. Paper-backed foil is elegant in appearance but more difficult to work with than regular paper. You will find this material in two weights. The lightweight variety is thin like candy foil and the medium weight is of greater thickness. Both types may be found in pre-cut squares that are sold as packaged origami paper. Medium weight paper-backed foil is also available in rolls at arts and crafts supply stores and at party supply stores.

Scrapbook papers are not required for any of the projects, but are an interesting option for some. These papers are sold at arts and crafts supply stores. They are generally a little thicker than medium weight bond paper and are printed in a multitude of designs. Scrapbook paper varies in weight and durability. So, buy just one or two sheets of a design or type and test them before buying several.

OTHER SUPPLIES

Although paper and your enthusiasm are the most important "supplies" that you will need, there are a couple of other items that will be helpful. A hard surface to fold on is useful for all—but essential for a beginner. The smooth surface of a table or desk works great and even the cover of a sturdy book will do. Even though you will be folding without cutting, you may wish to use scissors to prepare squares from bond paper. Refer to pages 16 and 18 for instructions on how to make squares from rectangular sheets of paper. You may also use scissors to cut the eight-inch square folding papers into four-inch squares when required by the instructions for a few projects. It's easy to cut a square into four smaller squares. First, fold the bottom edge of the square to the top edge and unfold. Next, fold the right edge to the left edge and unfold. Finally, cut along the creases.

TERMS AND SYMBOLS

This section introduces you to the language of origami. The word "model" is a general term that refers to what you are folding, have folded, or will fold. So, at any stage of folding, the paper in your hand may be referred to as a "model." You can also talk about the "model" that you made or the "model" that you plan to fold.

Illustrated instructions are a great help in explaining how to fold a model. The illustrations show the model opened up a bit so that you can see the layers of the folded paper within. The written directions that accompany the illustrations

include helpful terms that enable you to relate locations on the model to the drawing. The "top" of your model corresponds to the part of the drawing that is closest to the top of the page. A similar relationship exists for each of the terms "bottom," "left," and "right." These and other commonly used terms are depicted in the illustrations below:

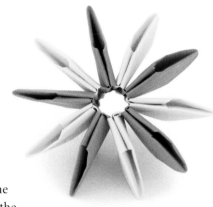

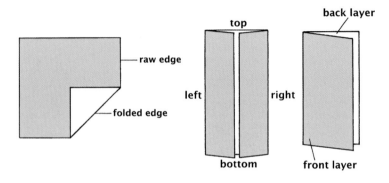

Now, let's increase your vocabulary with some origami lingo. When you open a sheet of folded paper, that action results in a mark being left on your paper by the fold that you made. In the language of origami, we refer to this mark as a "crease." If you fold paper and then open that fold, in origami terminology, you are said to "crease" paper. A fold that does not extend from one edge of the paper to the other is called a "partial fold." A partial fold that has been opened is called a "partial crease." A "landmark" is a short partial crease that is used to mark a location on the model.

A fold is either classified as a "valley fold" or a "mountain fold." A valley fold is the one that you are probably most used to making. When you open a valley fold, the shape of the crease that is left on the paper is a depression. The shape of this type of crease is suggestive of a valley and is called a "valley crease."

In order to make the text easier to read, origami instructions will often substitute the word "fold" for the term "valley fold." For example, instead of saying "valley fold the bottom corner to the top corner," the instructions will read "fold the bottom corner to the top corner."

The other type of fold is a mountain fold. When you open a mountain fold, the crease that is left on the paper is ridge-shaped. The shape of this type of crease is suggestive of a mountain and is called a "mountain crease." The illustrations below depict these terms.

Notice that, in the illustration, the raw and folded edges are represented by a thicker line than the crease lines. In addition, although the creases actually extend from edge to edge, they are drawn a little shorter. Often creases will be illustrated in this manner.

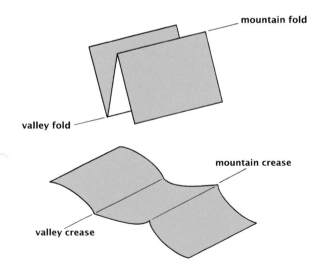

LIST OF SYMBOLS

Make a valley fold on your model on the indicated line.

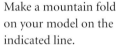

Fold the paper so that your hand moves in the direction of the arrow.

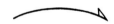

Make a mountain fold on your model on the indicated line.

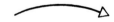

Fold the paper away from you in the direction of the arrow.

Open a previously made fold.

This type of arrow combines two actions. (This symbol means to fold the paper and then open that fold.)

This symbol depicts a line that is hidden from view or a guide line.

Insert or tuck the flap where the arrow indicates.

Line up the dots when making the fold indicated by the arrow.

Repeat a procedure on the model at the location pointed to by the arrow.

Push the paper in the direction of the arrow with your finger.

Turn the model over in the direction of the arrow.

Rotate the model in the direction of the arrows for the specified fraction of a turn.

The next step will be illustrated from the indicated vantage point.

Fold (or unfold) the paper to form an angle of the specified degree.

Hold the model at the location indicated by the circle.

Blow a puff of air in the direction of the arrow.

After looking over the group of symbols, you may be wondering how they are used together. So, here's a sneak preview. The following are examples of how line and arrow symbols are combined to make the folds and creases that you learned about earlier:

valley fold:

valley crease:

mountain fold:

mountain crease:

FOLDING TIPS

Let's talk about some good habits that will make folding easier and more enjoyable:

Fold on a hard surface. This is especially important for beginners.

Beginners should press all folds well. It may be helpful, however, to first make a gentle fold and check its location before pressing down hard.

Sometimes you will find it simpler to create a mountain fold by turning the paper over, making a valley fold, and then returning the paper to its original position.

READING THE DIAGRAMS

Understanding origami diagrams is simpler than you might expect. Before starting, keep the following tips in mind:

Carefully read the written instructions for every step. When working on a particular step, look at the diagram of the step that follows it to see what the result will look like.

Change the position of a model to any one that you are comfortable with while folding. Just be sure to return the model to the same position as shown in the illustration before going on to the next step.

If you feel unsure about what to do at a particular step, read ahead to the next step. Sometimes by going ahead, the preceding step will become clarified.

Here's a little exercise to get you started. The illustrated steps that follow and their accompanying written instructions include an explanatory discussion of what is being depicted and what you should look for. Work through the steps with a square of paper in your hand—any type of paper will be fine.

1 If you are using origami paper, start with the white side facing you. Position the square with a corner toward you. Fold the bottom corner to the top corner.

Discussion: Before making the fold, it is important to study the details of the illustration. Check the direction of the arrow—it shows that the bottom corner is folded up to the top corner. Look carefully at the location of the valley-fold line. Notice that it connects the left and right corners of the paper.

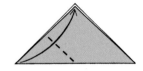

2 The illustration shows the result of step 1. Fold the left corner to the top corner.

Discussion: Before making the fold, find each location referred to in the written instructions. Check for the location on the illustration and on your model. It is helpful to look ahead to the next step's illustration. This will show what the completed step will look like and give you confidence to make the fold.

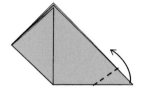

3 Fold the right corner up and to the left.

Discussion: The instructions in steps 1 and 2 referred to specific locations on the model where the folds should be made. Sometimes, instead, it is necessary to estimate where to place the fold. This is called a "judgment fold." The fold in this step is an example of a judgment fold. Before making the fold, it is essential to look at both the illustration of the step you are on as well as that of the next step.

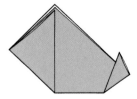

4 You are now ready to learn how valley folds and mountain folds are used together.

BASIC TECHNIQUES

In this section, you will learn valuable and exciting origami techniques. You will find out how to combine valley folds with each other and with mountain folds. Various combinations of these folds create interesting and well-known forms that are an integral part of origami designs.

Learning each of the basic techniques that follow will be easy and will fit right into your coffee breaks. You only need to do these exercises as you need them! At the beginning of the instructions for each model, you will find a listing of the basic techniques required. The techniques in this section are listed in the order that they appear in the book. If you want to stay "one up" on what is needed, then periodically complete an additional basic technique exercise before you go on to the next model and you will be well-prepared. For each exercise, you can use a square of any type of paper that you have available.

Diamond Base

A "base" is a form that is produced by a particular sequence of folds. In origami instructions, a base sometimes serves as the starting point for making a model. This first base that you will make has a plain but useful shape and is most often used as a base for simple designs.

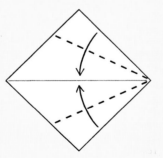

2 Open the fold that you made in the last step.

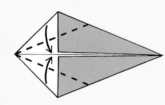

4 Fold the bottom left edge to the crease. Fold the top left edge to the crease.

6 You have made your first base—the Diamond Base.

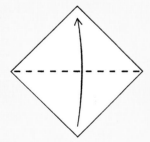

1 Start with the white side of the paper facing you. Fold the bottom corner to the top corner.

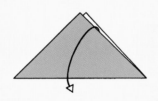

3 Fold the bottom right edge to the crease. Fold the top right edge to the crease.

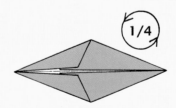

5 Rotate the model so that it is in the position illustrated in the next step.

Reverse Fold

Making a reverse fold is a common technique used in origami. In this exercise, you will fold examples of the two types of reverse folds—an inside reverse fold and an outside reverse fold.

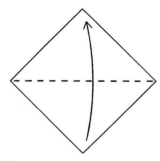

1 Start with the white side of the paper facing you. Make a valley fold by folding the bottom corner to the top corner.

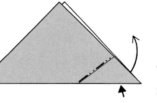

2 Prepare for the inside reverse fold that you will make by folding the right corner upward. Beginners should make this fold sharply.

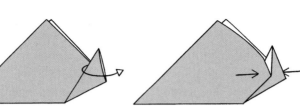

3 Open the fold that you just created. (It may be helpful for beginners to also make a mountain crease on this valley crease so that the reverse fold will be easier to make.)

4 Make an inside reverse fold by following the procedure taught by steps 5 and 6. The result is shown in step 7.

5 Spread the layers of the model apart. Begin to push the flap inside the model.

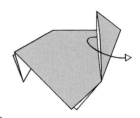

6 Continue pushing the flap inside the model. Press the sides of the flap together as you close and flatten the model.

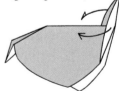

7 The illustration shows the inside reverse fold that you just made. For some inside reverse folds, the reversed corner will be hidden inside the model. Turn your model upside down by rotating it to the position shown in the next step.

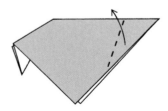

8 Prepare for the outside reverse fold by folding the right corner upward. Beginners should make this fold sharply.

9 Open the fold that you just created. (It may be helpful for beginners to also make a mountain crease on this valley crease.)

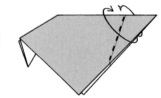

10 Turn the indicated portion of the flap inside out, wrapping the layers around the model. Take care not to tear the paper. (The model will partially open during this process.)

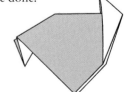

11 The illustration shows the procedure in progress. Close and flatten the model after you are done.

12 The illustration shows the outside reverse fold that you just made.

Squash Fold

The term "squash fold" is descriptive of this next type of fold.

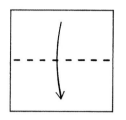

1 Start with the white side of the paper facing you. Fold the top edge to the bottom edge.

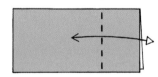

2 Fold the double edge on the right side of the model to the left. Unfold.

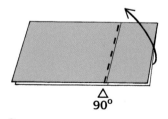

90°

3 Using the crease made in the last step, fold the right portion of the model so that it stands up.

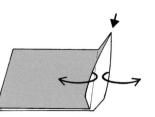

4 Insert a finger into the pocket to spread it open as you push down from above, flattening the flap in a symmetrical fashion.

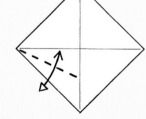

5 The completed squash fold.

Rabbit Ear Fold

Making a rabbit ear fold is one way of creating a new flap.

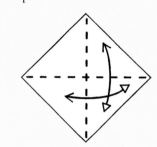

1 Start with the white side of the paper facing you. Fold the bottom corner to the top corner. Unfold. Fold the right corner to the left corner. Unfold.

2 Bring the left bottom edge to the horizontal crease. Make a partial fold by pressing the paper starting at the left corner and ending at the crease. Unfold.

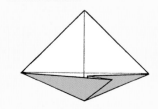

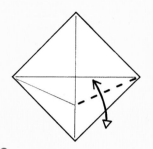

3 Bring the right bottom edge to the horizontal crease and make the indicated partial crease.

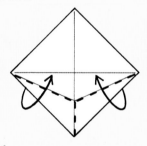

4 Pinch the left and right sides of the bottom corner together as you fold up on the valley creases which will cause a raised flap to form.

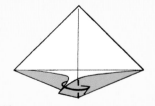

5 Fold the flap to your right. The flap will rest flat against the model.

6 Your rabbit ear fold is complete.

Waterbomb Base

The Waterbomb Base is a well-known base.

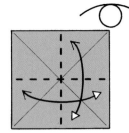

3 Fold the bottom edge to the top edge. Unfold. Fold the right edge to the left edge. Unfold. Turn the model over so that its white side is facing you.

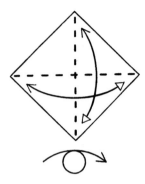

1 Start with the white side of the paper facing you. Fold the bottom corner to the top corner. Unfold. Fold the right corner to the left corner. Unfold. Turn the model over so that its white side is facing away from you.

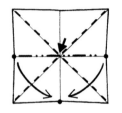

4 Push the center point causing it to recede. Next, bring the midpoint of each side edge down to the midpoint of the bottom edge.

2 Rotate the model to the position shown in the next step.

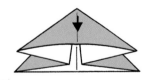

5 Press on the front flap to flatten the model.

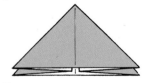

6 The Waterbomb Base brings the midpoint of each of the four sides of the square together.

Fish Base

The Fish Base has been used to create fish models as well as other types of designs.

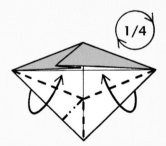

1 Start with the completed rabbit ear fold as shown in step 6 of the last exercise. Turn the model upside down by rotating it to the position shown in the next step.

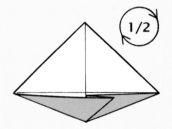

2 Make the rabbit ear fold so that the new flap that is formed points to the left. Next, rotate the model to the position shown in the next step.

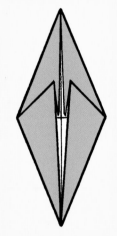

3 The Fish Base includes two rabbit ear folds.

Pinwheel Base

The Pinwheel Base is a useful base and an interesting one to make.

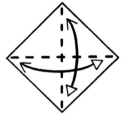

1 Start with the white side of the paper facing you. Fold the bottom corner to the top corner. Unfold. Fold the right corner to the left corner. Unfold.

2 Rotate the model to the position illustrated in the next step.

3 Fold the bottom edge to the top edge. Unfold.

4 Fold the bottom edge to the center crease. Unfold. Fold the top edge to the center crease. Unfold.

5 Rotate the model so that the creases that you just made are in a vertical position.

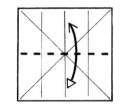

6 Fold the bottom edge to the top edge. Unfold.

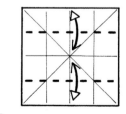

7 Fold the bottom edge to the center horizontal crease. Unfold. Fold the top edge to the center horizontal crease. Unfold.

8 Fold each side edge to the center vertical crease.

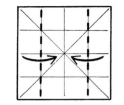

9 Fold A down to B. The model is now three-dimensional.

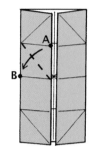

10 Fold C down to D.

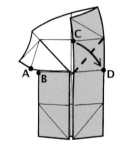

11 Bring the top edge down and press the model flat.

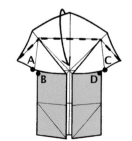

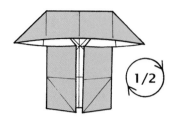

12 Rotate the model so that it is in the position shown in the next step.

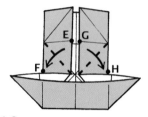

13 Fold E down to F and fold G down to H.

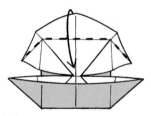

14 Bring the top edge down and press the model flat.

15 This is one form of the Pinwheel Base. It is the form that will be used in this book.

Preliminary Base

Making a Preliminary Base is a common procedure that you will perform as you fold origami models.

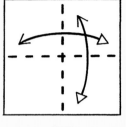

1 Start with the white side of the paper facing you. Fold the bottom edge to the top edge. Unfold. Fold the right edge to the left edge. Unfold. Turn the model over so that its white side is facing away from you.

2 Rotate the model to the position shown in the next step.

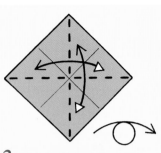

3 Fold the bottom corner to the top corner. Unfold. Fold the right corner to the left corner. Unfold. Turn the model over so that its white side is facing you.

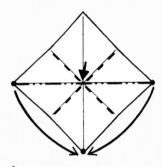

4 Push the center point causing it to recede. Next, bring both the left corner and the right corner down to the bottom corner.

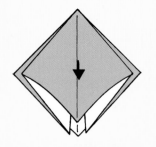

5 Push down on the front flap and flatten the model.

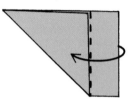

6 The Preliminary Base brings all four corners of the square together.

Making One Square from a Rectangle

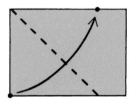

1 Fold the bottom left corner to the top edge.

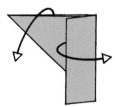

2 Fold the narrow section to the left.

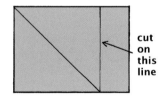

3 Open both flaps.

4 If you started with an 8½ by 11 inch sheet of paper, the result will be an 8½-inch square.

cut on this line

Flower Base

The following sequence of folds has been used to create flowers as well as other types of origami models.

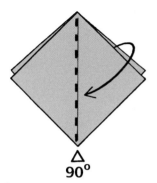

1 Start with a completed Preliminary Base. You will be making a squash fold on the right front flap. First, stand the flap up.

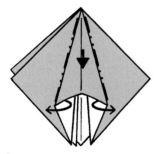

2 Insert your finger into the pocket to open it up and then push down on the flap flattening it in a symmetrical fashion.

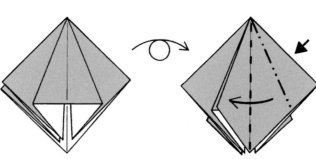

3 Completed squash fold. Turn the model over to the position shown in the next step.

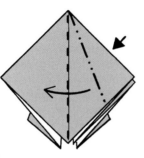

4 Make a squash fold on the right front flap by following the procedure shown in steps 1–2.

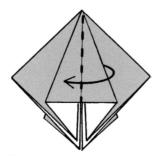

5 Fold the right front flap to the left.

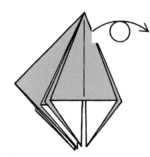

6 Squash fold the right front flap.

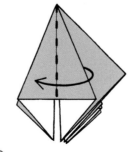

7 Turn the model over to the position shown in the next step.

8 Fold the right front flap to the left.

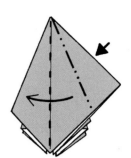

9 Squash fold the right front flap.

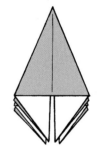

10 Your Flower Base is complete.

Making Two Squares from a Rectangle

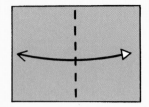

1 Start with an 8½ by 11 inch sheet of paper. Fold the right edge to the left edge. Unfold.

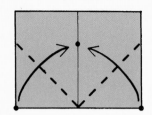

2 Fold each bottom corner to the crease.

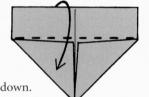

3 Fold the top edge down.

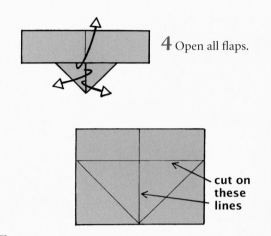

4 Open all flaps.

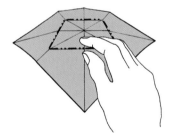

cut on these lines

5 The result will be two 5½-inch squares. Generally, you can use a 5½-inch square of bond paper when paper requirements recommend a 6-inch square of bond paper.

Sink Fold

Making a sink fold is a procedure that pushes a point inside the model and is often used to shape it.

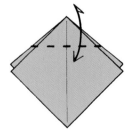

1 Start with a completed Preliminary Base. The type of arrow shown instructs you to make a valley crease and then make a mountain crease in the same location. These creases are for a sink fold, so make them sharply.

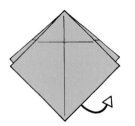

2 Partially unfold the model so that the white side is facing away from you and the area that will be involved in the sink is flattened out.

3 With your thumb and index finger, pinch mountain folds along the creases that outline the square that you will sink fold. Then bring the four corners of the model down below the square area so that the model looks like the illustration of step 4.

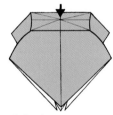

4 Push in the square area inside the model as you flatten the model along existing creases.

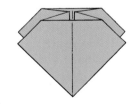

5 You have made a sink fold.

Coffee-Break Origami

This chapter includes thirteen models that are perfect for those moments when you have a brief period of time to yourself—a coffee break or when waiting in the car to pick up your kids. At these special times, you will create colorful ornaments, entertaining toys, and novelties inspired by the beauty of nature. All of these items look lovely on display or make well-appreciated gifts. Each of the first eight models is folded from a single sheet of paper and can be completed in one coffee break.

The remaining five models are each made from two or more squares of paper. For those five models, in a single coffee break you will be able to complete at least one portion of the final creation. For example, there is a three-piece puzzle in which you can make one or more pieces per break. The last four projects are modular origami. Modular origami models are made from more than one sheet of paper. Each sheet of paper is used to form a module, also known as a "unit," and later these are joined to form the completed model. The units connect to each other purely by folds. All of the modular designs in this chapter are created from units that you can make during your short breaks. The first modular design that you will encounter is constructed from units that can be connected in a few seconds. The units for the other three modular models can be assembled during a coffee break.

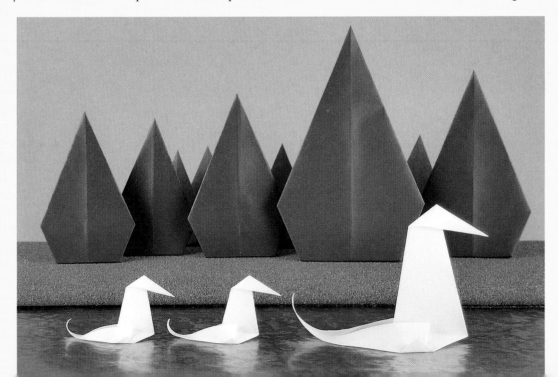

Duck Glider

Created by Marcia Joy Miller

Given a puff of air, Duck Glider will sail across the top of your table. When made from aluminum foil, the model will coast across water.

PAPER: Create the model from the designated sheet of folding paper included in the back of the book on page 97. You can also fold the model from a 6-inch square of origami paper or lightweight bond paper. For a waterproof version, use a 6-inch square of aluminum foil.

BASIC TECHNIQUES: A knowledge of how to make a valley fold and a mountain fold is all that is needed (see Chapter 1—Terms and Symbols).

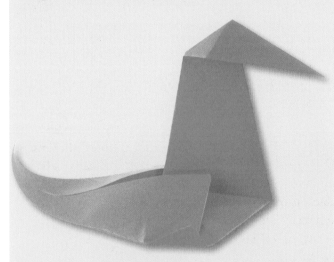

If you make the duck from aluminum foil for use as a water toy, place it on the surface of the water and blow gently at its tail.

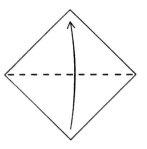

1 If you are using the included folding paper, start with the solid-color side facing you. If you are using origami paper, start with the white side facing you. Fold the bottom corner to the top corner.

2 Open the fold that you just made.

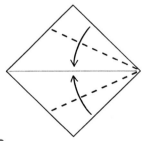

3 Fold the bottom right edge to the crease. Fold the top right edge to the crease.

4 Fold the right corner to the left corner.

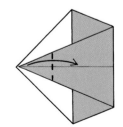

5 Fold the left corner of the flap to the right.

6 Mountain fold the top half of the model away from you along the existing crease.

7 Pick up the model. Pull the flap (that will be the neck of the duck) up and to your right.

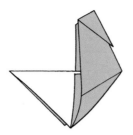

8 Line up the bottom of the new fold being formed with the bottom point of the model. It's okay if it does not line up perfectly. Press the new fold flat.

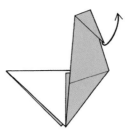

9 Now, form the duck's head by the same method. Pull the top flap up and to the right. Press the new fold flat.

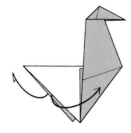

10 Bring the front flap toward you and move the back flap away from you so that you may set the model flat on the table. You will have to hold the area on the left down with your hand so that the model does not tip to the right.

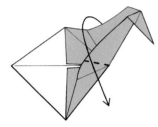

11 Fold the neck toward you.

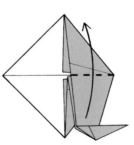

12 Fold the neck away from you.

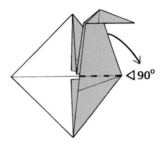

13 Bring the neck toward you standing it up at a right angle to the rest of the model and to the table.

17 Place the duck on a smooth surface such as a table top. Blow a puff of air directed under the tail causing your Duck Glider to "swim."

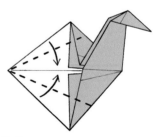

14 Fold the raw edge closest to you to the center crease. Fold the raw edge furthest from you to the center crease.

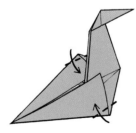

15 Fold a little flap on the corner near you. Fold a little flap on the corner furthest from you.

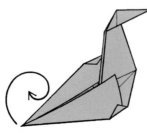

16 Curl the tail of the duck around a cylindrical object such as the barrel of a ballpoint pen.

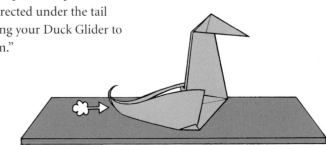

Placard Bird

Created by Barry B. Miller

This charming place card holder can be used to decorate a table setting. Placard Bird, with its wings outstretched, greets each of your guests personally. It's perfect for a child's birthday party.

PAPER: Make the model from a 4-inch square using the designated folding paper included in the back of the book on page 101. (See the instructions under the subheading "Other Supplies" in Chapter 1 to learn how to make a 4-inch square from an 8-inch square.) You can also use a 5½-inch square of medium weight bond paper.

BASIC TECHNIQUES: See Chapter 1 for the Rabbit Ear Fold exercise.

1 Fold the bottom corner to the top corner. Unfold. Fold the right corner to the left corner. Unfold.

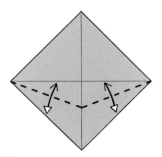

2 Bring the right bottom edge to the center horizontal crease and make a partial crease. Next, bring the left bottom edge to the horizontal crease and make a partial crease.

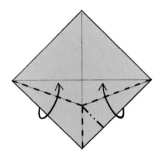

3 Make a rabbit ear fold by pinching the left and right sides of the bottom corner together as you fold up on the valley creases made in the last step. Fold the short flap that forms in the center to the right.

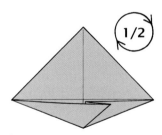

4 Rotate the model to the position shown in the next step.

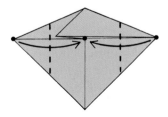

5 Fold the right corner to the indicated point on the center vertical crease. Fold the left corner to the same indicated point on the center vertical crease.

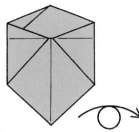

6 Turn the model over so that it looks like the position shown in the next step.

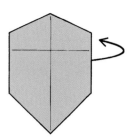

7 Pick up the right edge releasing the flap underneath.

8 Bring the mountain fold to the vertical crease and press the new fold flat.

9 Pick up the left edge releasing the flap underneath.

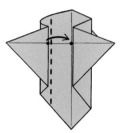

10 Bring the mountain fold to the vertical crease and press the new fold flat.

11 Fold the bottom corner up to the indicated point. (Note: the point that is referred to is located approximately halfway between the horizontal crease and the top corners of the front flaps.)

12 Turn the model over so that it looks like the position shown in the next step.

13 Make a little valley fold at the top right corner. Fold the front flap (it will be the beak) to the right.

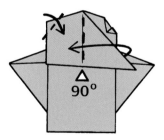

14 Make a little valley fold at the top left corner. Stand the flap (that will be the beak) up at a right angle.

15 Pull down the bottom back flap to an angle that is a little less than a right angle.

16 Cut a rectangle from card stock or medium weight bond paper that you will use as a place card and then insert the card under the flap of the model. Your Placard Bird is ready for company.

Barry B. Miller is interested in science and protecting the enviroment. He likes antique microscopes, exotic houseplants, and mineral collecting.

Seahorse

Created by Marcia Joy Miller

Folding this cute seahorse may bring a smile to the face of even the most serious of folders!

PAPER: Create the model from the designated sheet of folding paper included in the back of the book on page 103. You can also use a 6 to 10-inch square of origami paper.

BASIC TECHNIQUES: See Chapter 1 for the Reverse Fold, Rabbit Ear Fold, and Fish Base exercises.

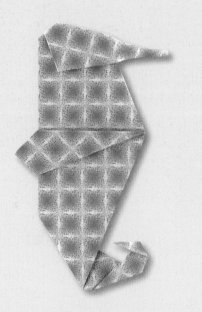

You can create a scene with Seahorse and Aquatic Plant (taught next in this chapter). Paste them on blue cardboard or make a diorama.

1 Start with a completed Fish Base. (If you are using the included folding paper, begin the Fish Base with the solid-color side facing you.) Mountain fold the Fish Base in half by folding the left side behind the right side.

2 Fold the front flap down. Repeat the fold with the back flap.

3 Fold the bottom edge of the front flap to the crease. Repeat the fold on the back flap.

4 Fold the left corner of the flap away from you so that it touches the bottom corner of the same flap. (Note: another option, which a little more challenging, is to make inside reverse folds.)

5 Make an inside reverse fold. (Hint: First make a valley crease and then a mountain crease at the line for the fold. Then spread the folded edges at the right apart and push the bottom part of the flap between them.

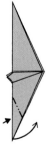

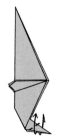

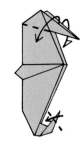

6 This time, make an outside reverse fold. (Hint: First make a valley crease and then a mountain crease at the line for the fold. Then turn the bottom portion of the flap inside out, wrapping its layers around the model.)

7 The illustration shows the outside reverse fold in progress.

8 The outside reverse fold is complete. Now make an inside reverse fold which will begin to form the head.

9 Fold the front top edge of the head towards you and the back top edge away from you. Shape the tail with a valley fold.

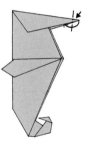

11 Steps 11–12 show only the head. Shape the head by making a small mountain fold.

10 Push the corner completely inside the head by making an inside reverse fold.

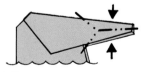

12 Push down on the top edge while you push up on the bottom edges causing mountain folds (that are partially open) to form.

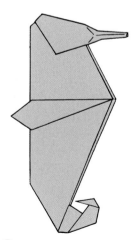

13 Your seahorse is complete.

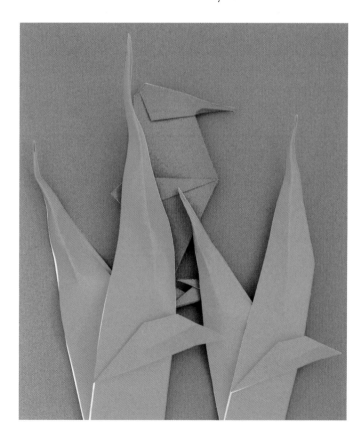

Aquatic Plant

Created by Marcia Joy Miller

Plant life adds realism to origami nature scenes. Aquatic Plant can be displayed against a flat background to suggest an underwater scene. The instructions also explain how to modify the plant so that it may be inserted into a Styrofoam base or used as a terrestrial plant.

PAPER: Make the model from the designated sheet of folding paper included in the back of the book on page 105. You can also use a 10-inch square of origami paper.

BASIC TECHNIQUES: See Chapter 1 for the Rabbit Ear Fold and Fish Base exercises.

SPECIAL INSTRUCTIONS: Make sharp folds.

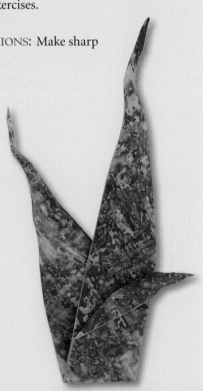

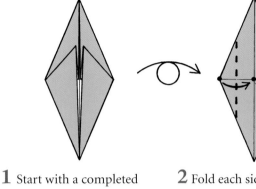

1 Start with a completed Fish Base. (If you are using the included folding paper, begin the Fish Base with the solid-color side facing you.) Turn the model over so that it looks like the position shown in the next step.

2 Fold each side corner to the middle of the center crease.

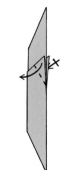

3 Fold the right side to the left side.

4 Fold the indicated flap to the left making an angled fold. Repeat the fold with the back flap.

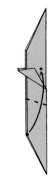

5 Make the fold by matching the dots.

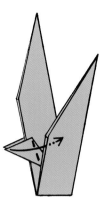

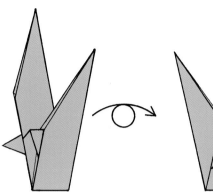

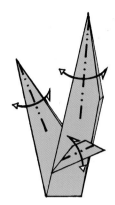

6 Tuck the small flap in between the layers of the right flap.

7 Turn the model over so that it looks like the position shown in the next step.

8 Make a small mountain fold on the indicated corner of the front flap.

9 Shape the left flap so it will have a little depth by pinching a mountain crease through all its layers. Perform a similar procedure with the other two flaps.

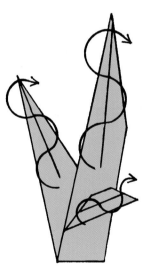

11 The flap that you tucked in step 6 may have slipped out of place. If it has, then tuck it in again. Your completed Aquatic Plant will look great displayed on a flat backing, such as posterboard or the background of a diorama. By including several plants you can create an interesting scene. For variety, you can include plants of different sizes—some of which have the short flap on the left.

10 If you are making a plant for an underwater scene, rumple each flap by bending it back and forth between your fingers.

For a version of the plant that may be inserted into a Styrofoam base, mountain fold the bottom corners back so that they overlap somewhat. The photograph shows the model made as a terrestrial version (without rumpling the leaves).

Parrot Page Clip

Created by Marcia Joy Miller

This parrot boldly perches on top of a few sheets of paper fastening them together.

PAPER: Make the model from a 4-inch square using the designated folding paper included in the back of the book on page 107. (See the instructions under the subheading "Other Supplies" in Chapter 1 to learn how to make a 4-inch square from an 8-inch square.) You can also use a square of memo cube paper or a 3½-inch square of bond paper.

BASIC TECHNIQUES: See Chapter 1 for the Reverse Fold exercise.

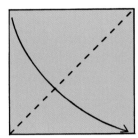

1 Fold the top left corner to the bottom right corner.

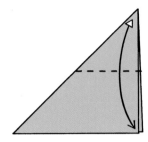

2 Fold the top corner to the bottom right corner. Unfold.

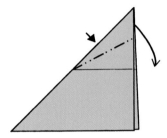

3 Make the inside reverse fold. (Tip: Before making the reverse fold, first sharply fold the upper portion of the left edge to the horizontal crease. Unfold. Then, make a sharp mountain crease on the new valley crease.)

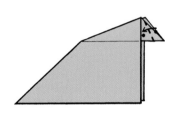

4 Bring the double edge to the left so that it rests a little to the right of the single edge.

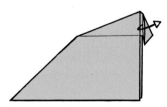

5 Open the fold that you made in the last step.

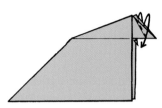

6 Make an outside reverse fold. (Tip: it is helpful to first make a mountain crease on the valley crease that you created in the last step.)

7 Make an eye by folding down the front edge. Repeat behind.

8 Stack two to four sheets of bond paper. Insert the stack of paper inside the model so that its left corner rests against the left corner of the inside fold of the model and the top edge of the stack rests against that inside fold.

9 Make sure that the stack of paper is behind the parrot's beak. Sharply fold the corner down and to the right catching the left corner of the stack of paper in the fold.

10 Your Parrot Page Clip neatly holds the sheets of paper.

Ghost

Created by Marcia Joy Miller

Make Halloween extra spooky this year by folding Ghost. It's a table decoration that is quick and easy to create.

PAPER: Make the model from the designated sheet of folding paper included in the back of the book on page 109. You can also use a 6-inch square of origami paper.

BASIC TECHNIQUES: See Chapter 1 for the Squash Fold and Waterbomb Base exercises.

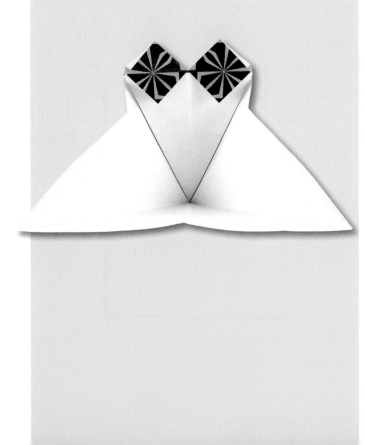

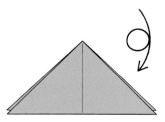

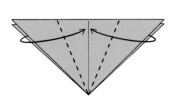

1 Start with a completed Waterbomb Base. Turn the model over from top to bottom so that it is in the position shown in the next step.

2 Fold the right edge of the front flap to the crease. Fold the left edge of the front flap to the crease.

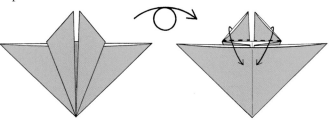

3 Turn the model over from side to side so that it is in the position shown in the next step.

4 Fold each top flap down against the raw edges.

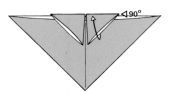

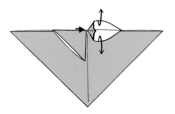

5 Prepare the right top flap for a squash fold. Stand it up at a right angle (90°).

6 Make a squash fold on the right top flap. (Insert a finger into the pocket of the flap to form a three-dimensional shape and then press the shape flat.)

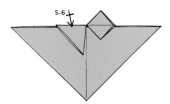

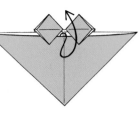

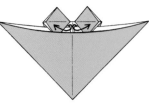

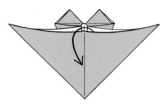

7 Repeat steps 5–6 on the left top flap. (In other words stand the flap up an angle, separate its left edges; and then, squash the flap.)

8 Pull the single front layer out from under the diamond-shaped flaps. The large flap is now in front of the diamond shapes.

9 Bring the two white flaps that are inside the model in front of the two diamond-shaped flaps.

10 Bring the front and middle layers toward you by pulling on the front flap. Stand the model.

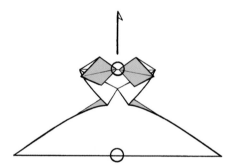

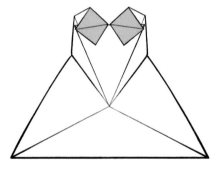

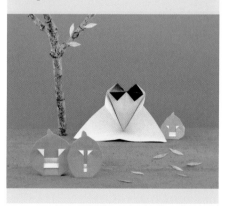

11 While holding down the bottom edge of the model with your left hand, grab the top with your right hand and stretch it up and away from you as far as possible. Repeat this process a few times so that the model will stand upright.

12 Notice that the front of the body has a concave shape. For an attractive Halloween decoration, display a pair of ghosts—one made from black origami paper and the other from orange origami paper.

Create a Halloween scene. The scene shown in the photograph includes Oval Leaf (taught in this chapter) and Jack-O'-Lantern (which is taught in the next chapter).

Lake Monster

Created by Marcia Joy Miller

Are lake monsters fact or fantasy? With origami, the answer is easy—the truth is in your hands.

PAPER: Create the model from the sheet of folding paper on page 111. You can also use a 10-inch square of origami paper.

BASIC TECHNIQUES: See Chapter 1 for the Reverse Fold, Rabbit Ear Fold, and Fish Base exercises.

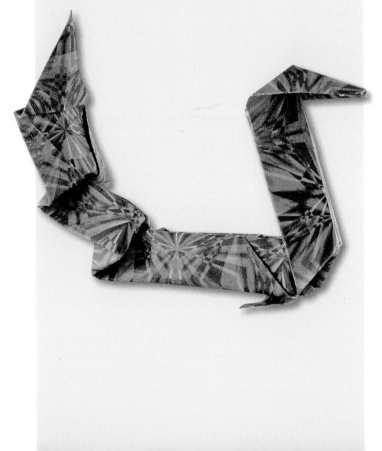

1 Start with a completed Fish Base. (If you are using the included folding paper, begin the Fish Base with the solid-color side facing you.) Turn the model over from side to side so that the flaps are on the back.

2 If you peek at the back of the model you will see that the short flaps are still pointing towards the top. Fold the right corner to the center point of the model. Fold the left corner to the center point of the model.

3 Rotate the model one-quarter turn clockwise so that the top corner will be positioned at the right.

4 Fold the bottom edge to the center horizontal crease. Fold the top edge to the center horizontal crease.

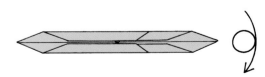

5 Turn the model over from top to bottom so that it looks like the position shown in the next step.

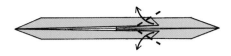

6 Notice that the two short flaps are positioned so that they are pointing toward the right. Fold the corner of the bottom flap downward so that its raw edges are in a vertical position. Fold the corner of the top flap upward so that its raw edges are in a vertical position.

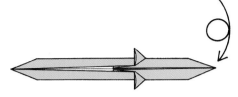

7 Turn the model over from top to bottom so that it looks like the position shown in the next step.

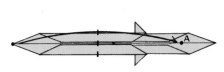

8 Notice that the raw edges of each small triangular flap are on the left side of the flap. Fold the left corner of the model to A.

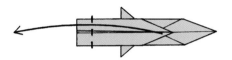

9 Fold the right corner of the front flap to the left as shown making a pleat with the flap. You have made a pleat fold.

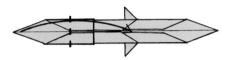

10 Fold the left corner to the right making a fold at the point where the slanted folded edges meet.

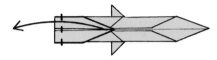

11 Fold the right corner of the front flap to the left completing a pleat fold.

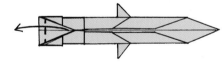

12 Fold the left corner to the right making a fold as indicated.

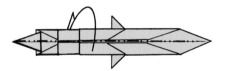

13 Complete the pleat fold by folding the right corner of the front flap to the left.

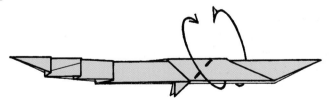

14 Mountain fold the model by folding the top half of the model behind the bottom half.

15 You will be making an outside reverse fold in this step and the next. Prepare for an outside reverse fold by folding the right corner up and a little to the left and then opening the fold. Look ahead to the illustration of step 17 to see the position of the reverse folded flap and use this illustration as a guide. (Beginners should also make a mountain crease on the valley-crease line.) Next, separate the edges that are to the right of the crease and push that portion of the flap up and to the left.

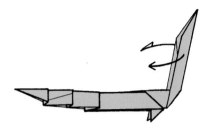

16 The illustration shows the outside reverse fold in progress. Bring the front and back portions of the flap together flattening the flap.

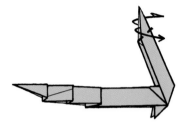

17 The outside reverse fold is complete. Next, make another outside reverse fold which will form the head.

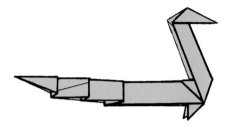

18 The illustration shows the completed outside reverse fold.

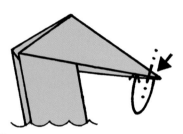

19 The illustration shows the head portion only. Make a small inside reverse by pushing the right corner under the flap.

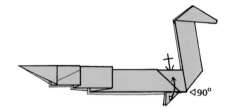

20 Fold the small triangular flap up and then unfold it so it is positioned at a right angle to the body of the model.

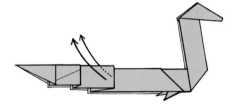

21 The purpose of steps 21–23 is to curve the tail. Grasp the three segments of the tail and slant them upward and to the right causing the rightmost pleat fold to change position. Flatten the new folds in front and in back.

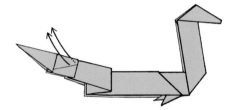

22 Grasp the left two segments of the tail and slant them upward and to the right causing the middle pleat fold to change position. Flatten the new folds in front and in back.

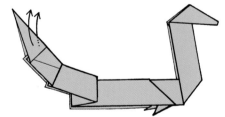

23 Grasp the leftmost segment of the tail and slant it upward and to the right causing the leftmost pleat fold to change position. Flatten the new folds in front and in back.

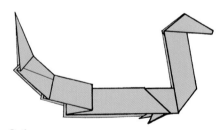

24 Your Lake Monster may be displayed on a table or shelf.

Oval Leaf

Created by Marcia Joy Miller

Decorate greeting cards or posters with Oval Leaf. You can also include it in nature scenes that you create from origami models. Make this simple leaf from paper that reminds you of fall colors and use it to enhance autumn displays.

PAPER: Create the model from the designated sheet of folding paper included in the back of the book on page 113. You can also use a square of 3 to 6-inch origami paper or bond paper in green or in autumn colors.

BASIC TECHNIQUES: See Chapter 1 for the Diamond Base exercise.

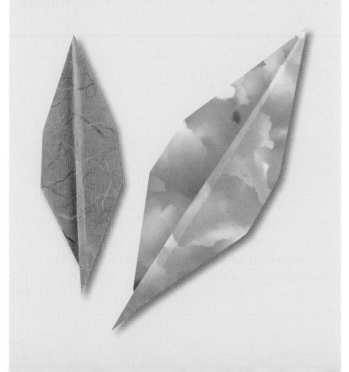

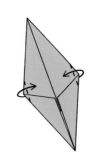

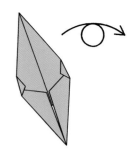

1 Start with a completed Diamond Base positioned as shown. (If you are using the included folding paper, begin the Diamond Base with the solid-color side facing you.) Make a small flap at each side corner to shape the leaf.

2 Turn the model over from side to side so that it is in the position shown in the next step.

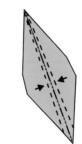

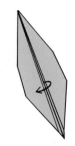

3 Keeping the model on the table, pinch along the crease making a ridge that is almost flat at the top corner and higher at the bottom corner. Run your fingernails against each side of the ridge creating valley creases.

4 Fold the ridge to the left for a right hand leaf or, if you prefer, fold the ridge to the right for a left hand leaf.

5 In Chapter 4, you will learn how to assemble foliage that includes Oval Leaf as a component.

Topsy-Turvy

Created by Marcia Joy Miller

Topsy-Turvy is a three-piece puzzle. The goal is to stack the individual pieces without having them topple over. Each piece of the puzzle can be completed during a coffee break.

PAPER: Use different color squares of medium weight bond paper in the following three sizes: 8½-inch, 7-inch, and 5½-inch. (Note: Make a 7-inch square by first cutting a 1½-inch strip from the long side of an 8½ by 11 inch sheet of bond paper. Then, cut a 7-inch square from the remaining 7 by 11 inch sheet.)

BASIC TECHNIQUES: See Chapter 1 for the Pinwheel Base exercise.

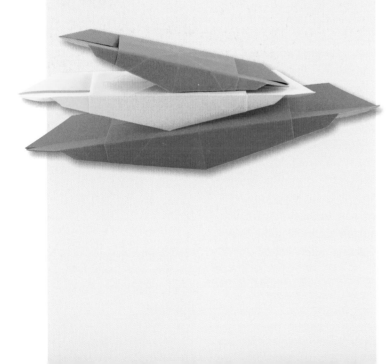

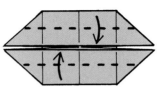

1 Start with a completed Pinwheel Base. Now, fold the bottom edge to the raw edge making a sharp fold. Make a similar fold on the top portion.

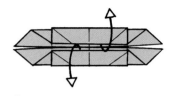

2 Open the two folds that you made in the previous step.

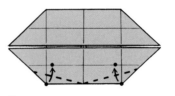

3 Fold the bottom right corner to the crease making a fold that begins at the bottom of the center vertical crease. Make a similar fold on the left side.

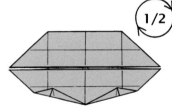

4 Rotate the model one-half turn so that the folds that you just made are located at the top.

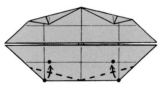

5 Fold the bottom right corner to the crease making a fold that begins at the bottom of the center vertical crease. Make a similar fold on the left side.

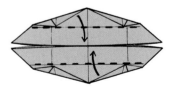

6 Fold the bottom edge to the center crease on the existing crease. Make a similar fold in the upper portion. Press the folds well.

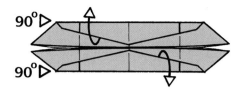

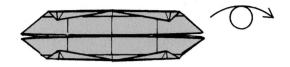

7 Partially open the top fold standing the flap up at a right angle (90°). Do a similar procedure with the bottom flap.

8 Turn the model over from side to side so that it looks like the position shown in the next step.

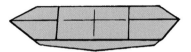

9 You have completed one puzzle piece. Now, fold two more puzzle pieces from the remaining squares of paper.

It is also possible to create and solve a four-piece Topsy Turvy. Make the fourth piece from a 4¼-inch square. Challenge yourself!

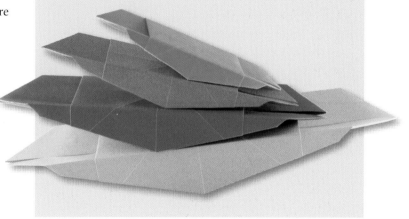

10 Try stacking Topsy-Turvy without having the pieces topple.

Friends

Created by Marcia Joy Miller

Friends is a modular origami model made from two units, each representing a child. If you try to stand the two children separately, each will topple over. However, when the two children "hold hands," they will stand. You can make each unit during a coffee break. They can be connected in a few seconds.

PAPER: Use two 5½-inch squares of medium weight bond paper in different colors.

BASIC TECHNIQUES: A knowledge of how to make a valley fold and a mountain fold is all that is needed (see Chapter 1—Terms and Symbols)

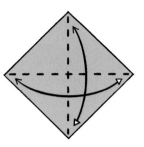

1 Start with one of the squares of paper. Fold the bottom corner to the top corner. Unfold. Fold the right corner to the left corner. Unfold.

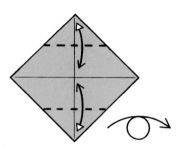

2 Fold the bottom corner to the center point. Unfold. Fold the top corner to the center point. Unfold. Turn the model over from side to side so that it is in the position shown in the next step.

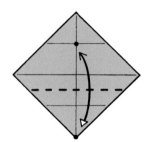

3 Fold the bottom corner to the crease that is furthest from it. Unfold.

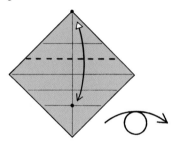

4 Fold the top corner to the crease that is furthest from it. Unfold. Turn the model over from side to side so it is in the position shown in the next step.

5 Make a pleat fold by bringing the second crease from the bottom up to the center crease and then pressing the new fold flat. (This procedure is shown in progress in the next step and the result is shown in step 7.)

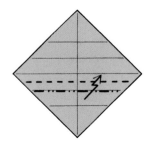

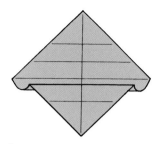

6 The illustration shows the pleat fold in progress.

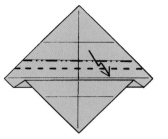

7 The illustration shows the completed pleat fold. Now, make a pleat fold in the upper portion of the model. So, bring the second crease from the top down to the indicated crease and press the new fold flat.

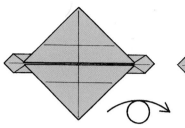

8 Turn the model over from side to side so that it is in the position shown in the next step.

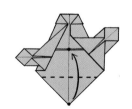

9 Further flatten the two horizontal mountain folds by pressing on them. Fold the top corner down to the mountain fold.

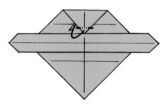

10 Make a mountain fold with the bottom corner of the flap.

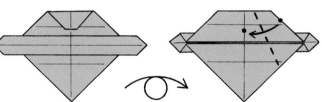

11 Turn the model over from side to side so it is in the position shown in the next step.

12 Fold the right upper edge to the center crease.

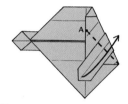

13 Make a fold on the front flap that starts at A and ends at the bottom right corner of the model.

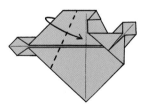

14 Fold the upper left edge to the vertical crease.

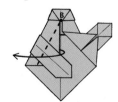

15 Fold the left flap to the left so that the fold begins at B and the resulting flap looks like an arm that is straight out from the body.

16 Fold the bottom corner to the point where the pleat fold and the vertical crease meet.

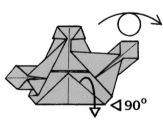

17 Open the flap to a right angle (90°). Turn the model around so that it is in the position shown in the next step.

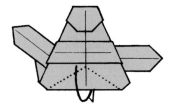

18 If you try to stand the model (with the back flap open to a full right angle) you will find that it will not stand or will tip over easily. Before proceeding, close the fold that you opened in the last step.

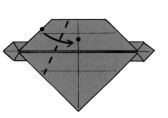

19 Now, prepare the second unit by completing steps 1–11 on the other square of bond paper. The result is shown in the illustration. Next, fold the left upper edge to the center crease.

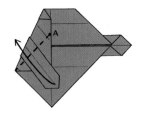

20 Make a fold on the front flap that starts at A and ends at the left bottom corner of the model.

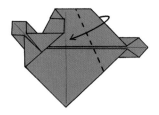

21 Fold the upper right edge to the vertical crease.

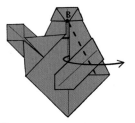

22 Fold the right flap to the right so that the fold begins at B and the resulting flap looks like an arm that is out straight from the body.

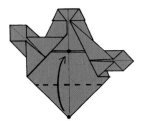

23 Fold the bottom corner to the point where the pleat fold and the vertical crease meet.

24 Place both units next to each other as shown above. Insert the pleat fold of the arm of the unit on the right into the one of the unit on the left as far as possible.

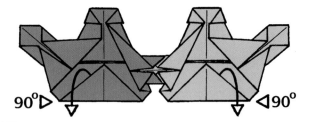

25 Unfold the bottom flap of each "friend" so that it is at a right angle (90°) to the rest of the model. Turn the model around and stand the model.

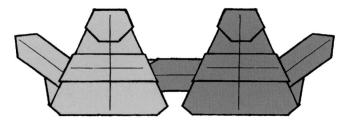

26 By cooperating, both friends can stand together.

Twirlie

Created by Marcia Joy Miller

Place this toy on your pencil, blow on it, and a splash of color whizzes around. Twirlie is a modular origami model. You can create the units during your coffee breaks and then connect them during another coffee break.

PAPER: Use medium weight bond paper. You will need either eight 8½-inch squares or ten 5½-inch squares. Choose an assortment of colors or an alternating pattern of two colors. After you are familiar with the model you can cut 8½-inch squares of bond paper into four smaller squares and use ten of these 4¼-inch squares to make Twirlie. Another choice for experienced folders is to create the model from twelve squares of memo cube paper.

BASIC TECHNIQUES: See Chapter 1 for the Preliminary Base exercise.

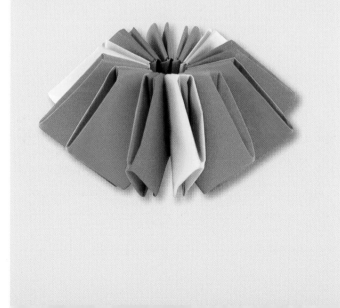

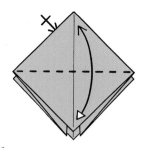 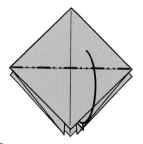

1 Start with a completed Preliminary Base. Fold the bottom corner of the front flap up to the top corner. Unfold. Repeat behind.

2 Mountain fold the bottom half of the front flap inside the model.

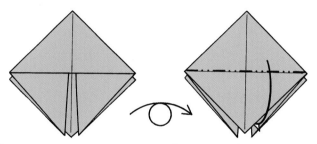

3 Turn the model over from side to side so that it is in the position shown in the next step.

4 Mountain fold the bottom half of the front flap inside the model.

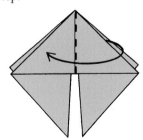 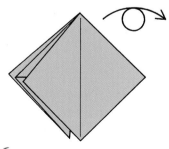

5 Fold the right front flap to the left.

6 Turn the model over from side to side so that it is in the position shown in the next step.

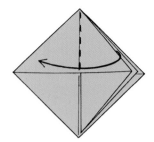

7 Fold the right front flap to the left.

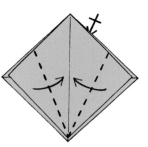

8 Fold the right bottom edge of the front flap to the crease. Fold the left bottom edge of the front flap to the crease. Repeat the process behind.

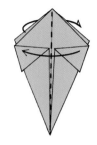

9 Swing the right front flap to the left. Swing the left back flap to the right.

10 Fold the bottom right flap up as far as possible.

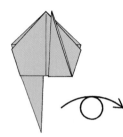

11 Turn the model over from side to side so that it is in the position shown in the next step.

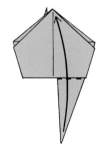

12 Fold the bottom right flap up as far as possible.

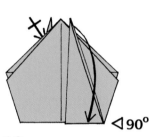

13 Bring the front flap towards you so that it is at a right angle (90°) to the rest of the model. Repeat behind.

14 You have completed one unit of what will be the finished model. Now, fold as many units as needed to complete one model. (See the paper requirements at the beginning of the diagrams to find out the number of units.)

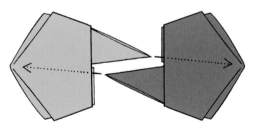

15 Pick up two units of different colors and position them as shown. Insert the top flap of the left unit partially into the top pocket of the right unit. Next, insert the bottom flap of the right unit partially into the bottom pocket of the left unit. Now, push both units together.

16 The illustration shows the connected units.

17 Now, swing the right unit to the left.

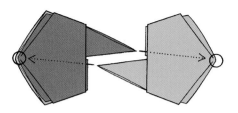

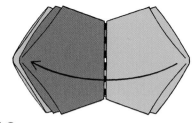

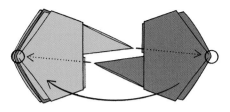

18 Hold the two units together with your left hand and position the third unit as shown with your right hand. Connect the right unit to the front left unit using a method similar to that done in step 15.

19 Swing the right unit to the left, holding the units together in your left hand.

20 Connect the single unit on the right to the front unit of the group on the left by using a method similar to that done in steps 18–19. Follow this procedure in order to connect all remaining single units to the group.

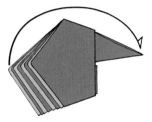

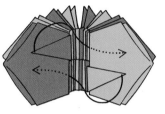

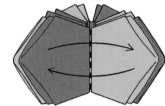

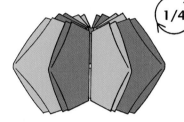

21 Let go of all the units except the front one allowing the back unit to swing around to the front.

22 Connect the two front units by a method similar to that done in step 15.

23 Position the two front units closer to each other. Make sure that you have pushed all the pointy flaps into the pockets of the large flaps as far as possible.

24 Arrange the units so that they are equidistant. Rotate the model one-quarter turn clockwise to the position shown in the next step.

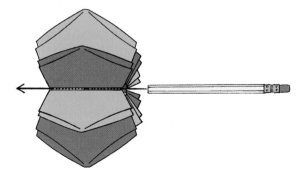

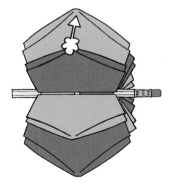

26 Directing your breath at the top of your Twirlie, blow on it and it will spin around your pencil. Experiment by folding Twirlie from different color combinations.

25 Insert a pencil (that does not have a point) into the hole that is formed by the connected units.

Trigon

Created by Marcia Joy Miller

Trigon is a triangular sculpture that may be displayed on a table or used as a hanging ornament. It is a modular design made from only three units. You can make each unit during a coffee break and connect them during another coffee break.

PAPER: Create the model from the three sheets of designated folding paper included in the back of the book on pages 115-120. You can also use three 6-inch squares of origami paper or medium weight paper-backed foil. After you are experienced with the model, you can also fold it from 3-inch squares of origami paper or medium weight paper-backed foil.

BASIC TECHNIQUES: See Chapter 1 for the Squash Fold and Preliminary Base exercises.

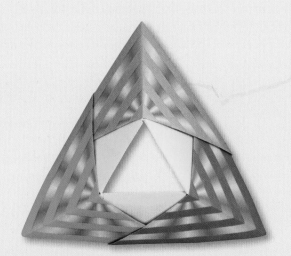

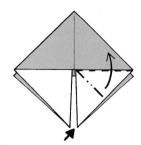

1 Start with a completed Preliminary Base. (If you are using the included folding paper, begin the Preliminary Base with the solid-color side facing you.) Mountain fold the bottom of the flap into the model. Repeat behind.

2 Squash fold the right flap.

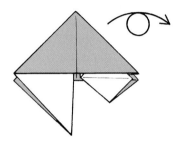

4 Turn the model over from side to side.

3 Tuck the top of the double layer under the triangular flap.

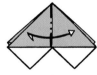
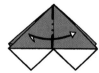
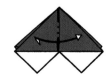

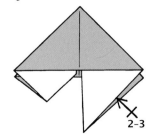

5 Repeat steps 2–3 on the right flap.

6 Make two more units from different colors. Make the indicated mountain crease on each unit.

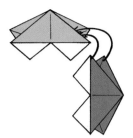 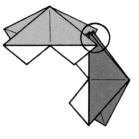 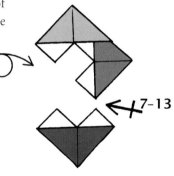

7 Position two units as shown. Place the right unit between the layers of the top unit.

8 Steps 9–10 show a magnified view of the circled area.

9 Notice that B identifies the right corner of the diamond-shaped flap that is underneath the front layer of the left unit. Insert B into the pocket that is near A.

10 Slide the two units toward each other as far as possible.

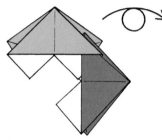 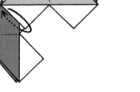 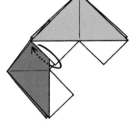

11 Turn the model over from side to side.

12 Tuck the left flap of the top unit under the front flap of the left unit.

13 Turn the model over from side to side.

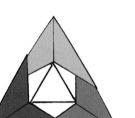

14 Connect the right and bottom units by repeating steps 7–13.

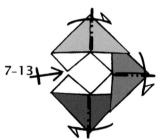

15 Bring the two unconnected units closer together by bending all three units in a mountain-fold fashion along their existing creases. Join the unconnected units by following steps 7–13. (Tip: before making this connection, temporarily pull the units of the upper connection a little apart.)

16 Your Trigon is complete. Display it in this position with its outside edges resting on a tabletop or turn it over for a different look. It looks especially nice as a hanging ornament.

Experiment with folding Trigon from various kinds of papers. An interesting paper to choose is duo-color origami paper. This paper has a different color on each side and is sold packaged as a type of origami paper.

Floating Star

Created by Marcia Joy Miller

When displayed as a hanging ornament, this dazzling nine-pointed star appears to be floating in the air. Floating Star is a modular origami design. Make the units during coffee breaks and connect them during another coffee break.

PAPER: Make the model from the nine sheets of designated folding paper included in the back of the book on pages 121-138. You can also use nine squares of 6-inch origami paper. To create a star that has the look of three intersecting triangles, choose three colors of origami paper—three squares of each color.

BASIC TECHNIQUES: See Chapter 1 for the Preliminary Base and Reverse Fold exercises.

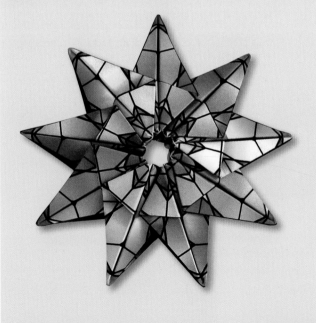

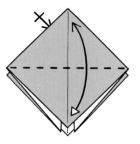 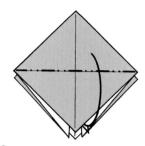

1 Start with a completed Preliminary Base. (If you are using the included folding paper, begin the Preliminary Base with the solid-color side facing you.) Fold the bottom corner of the front flap up to the top corner. Unfold. Repeat behind.

2 Mountain fold the bottom half of the front flap inside the model.

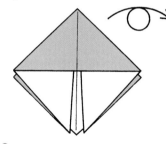 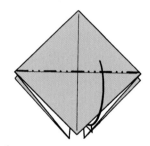

3 Turn the model over from side to side so that it is in the position shown in the next step.

4 Mountain fold the bottom half of the front flap inside the model.

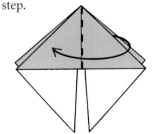 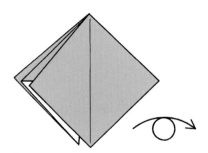

5 Fold the right front flap to the left.

6 Turn the model over from side to side so that it is in the position shown in the next step.

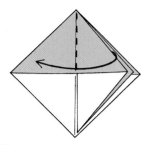

7 Fold the right front flap to the left.

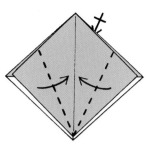

8 Fold the right bottom edge of the front flap to the crease. Fold the left bottom edge of the front flap to the crease. Repeat the process behind.

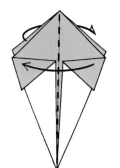

9 Swing the right front flap to the left. Swing the left back flap to the right.

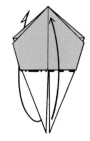

10 Valley fold the bottom right flap toward you in an upward direction as shown. Mountain fold the bottom left flap away from you in an upward direction as shown.

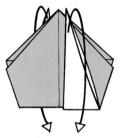

11 Open the folds that you just made in the last step.

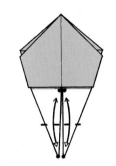

12 Fold the bottom tip of each of the lower flaps up to the indicated folded edge. Open the folds that you just made.

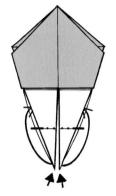

13 Make an inside reverse fold on each bottom flap.

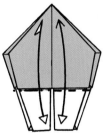

14 Valley fold the bottom right flap toward you on the existing crease and then unfold. Mountain fold the bottom left flap away from you on the existing crease and then unfold.

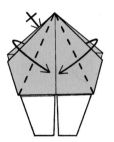

15 Fold each side of the front flap towards the center crease creating folds that begin at the top corner and end at the horizontal folded edge. Repeat behind.

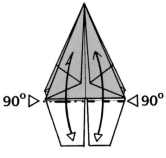

16 Sharply valley fold the right bottom flap toward you on the existing crease and then unfold so that it is at a right angle (90°) to the front of the model. Sharply mountain fold the left bottom flap away from you on the existing crease and then unfold it so that it is at a right angle to the back of the model.

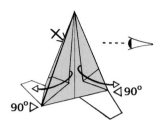

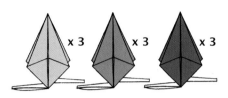

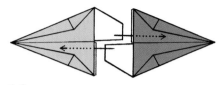

17 Open the two indicated flaps so that each is at a right angle to the model. Repeat behind. The next view of the model is from its side.

18 You have completed one unit. Make two more units in the same color, and three units for each of the two remaining colors.

19 The illustration shows the units from a side view as compared with the previous illustration. Position two units of different colors as shown. Insert the tab of the right unit into the pocket of the left unit and the tab of the left unit into the pocket of the right unit as indicated. Slide the units together as far as possible. The two back tabs will remain outside of the assembled units.

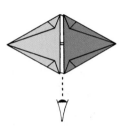

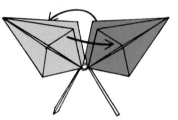

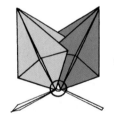

20 Turn the connected units so that they are in the position shown in the next illustration.

21 Move the units toward each other, placing the right front flap of the left unit in front of the right unit and the left back flap of the right unit behind the left unit. Hold them in place.

22 When you let go of the connected units the last step will become undone. Later, however, as you connect more units, this step will hold.

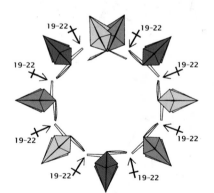

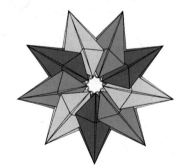

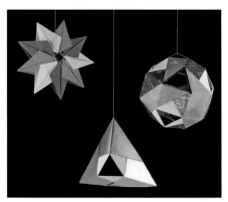

23 Connect all the units together by repeating steps 19–22 for each connection.

24 Check that the flaps of the star are positioned as instructed by steps 22–23. Adjust the units so that they are equidistant. Look at the back of the star to make sure the units are positioned properly. You are done!

Lunchtime Origami

In this chapter, you will find ten delightful models that you can work on in a reasonably short span of time, for example at lunchtime. During this quiet time you will create attractive objects with which to decorate your home and gifts that are fun and appealing. Included in this collection are a seasonal decoration and enjoyable things to fiddle with. Six of the models are each made from one square of paper and can be completed during a lunch break.

The remaining four models contain more than one component. There is a useful box that has a lid and a bottom, each of which can be completed during lunch. The other models are modular projects made from multiple squares of paper. You learned about modular origami in the introductory section of the last chapter. One or more units of the modular designs can be made during a coffee break or lunch break and then connected at lunchtime.

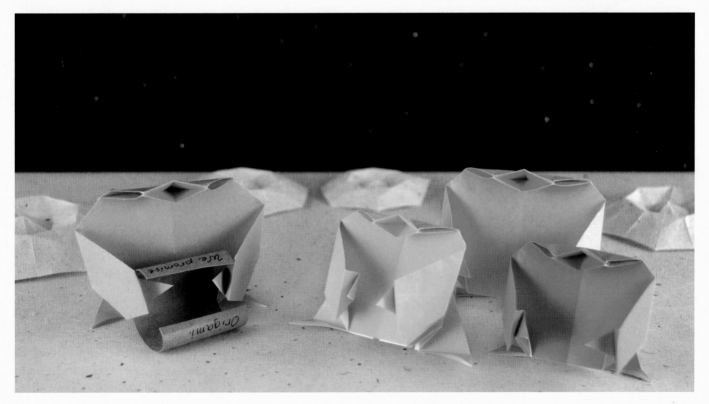

Noisemaker

Created by Marcia Joy Miller

Noisemaker is a fun toy with an interesting shape that can create quite a racket!

PAPER: For a model that produces the most sound, use a 5½-inch square of medium weight bond paper.

BASIC TECHNIQUES: See Chapter 1 for the Pinwheel exercise.

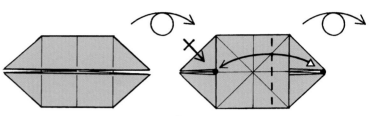

1 Start with a completed Pinwheel Base. Turn the model over from side to side so that it is in the position shown in the next step.

2 Fold the right corners to the leftmost vertical folded edge. Unfold. Repeat with the left corners. Turn the model over from side to side so that it is in the position shown in the next step.

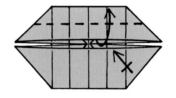

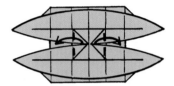

3 Fold the upper raw edge to the top edge. Repeat with the lower raw edge. The model is now three-dimensional.

4 Fold the right flap outward on the existing crease. Fold the left flap outward on the existing crease.

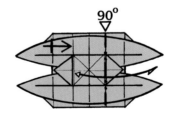

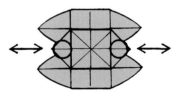

5 Mountain fold the right portion behind the model and then unfold to a right angle (90°) with respect to the back of the model. Repeat on the left.

6 Hold each of the flaps as indicated. Repeatedly, in a rapid manner, move the flaps away from each other and then toward each other.

Extraterrestrial

Created by Marcia Joy Miller

Add a touch of mystery to your origami display shelf with Extraterrestrial.

PAPER: Create the model from the designated sheet of folding paper included in the back of the book on page 139. You can also use a 6 to 10-inch square of origami paper.

BASIC TECHNIQUES: See Chapter 1 for the Reverse Fold and Waterbomb Base exercises.

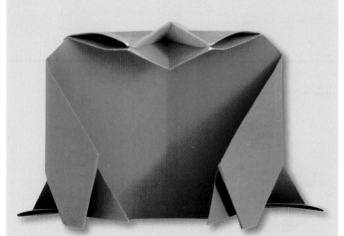

1 Start with a completed Waterbomb Base. Sharply fold the top corner down approximately one-third of the height of the model.

2 Sharply fold the corner to the top edge. Open the model completely.

3 Redefine the small center square with valley creases. Extend the top crease of that square to the edges.

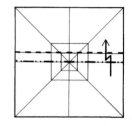

4 Make a pleat fold with the two long horizontal creases.

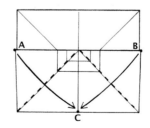

5 Bring A and B down to meet C. The result is three-dimensional.

6 Bring D down to meet A, B, and C. Then, flatten the model.

7 The front and back top edges differ in thickness. Keeping the thinner edge in front, make the partial creases using the triangular shape that you can feel within the layers as a guide.

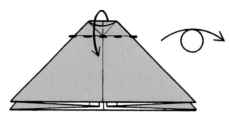
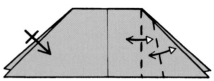

8 Fold the top edges down. Turn the model over from side to side.

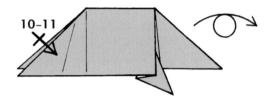

9 Make the creases on the right front flap. (The leftmost crease may be vertical or slightly angled.) Repeat on the left front flap.

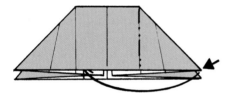

10 Make the inside reverse fold placing the reversed corner under the front layer.

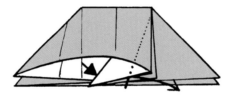

11 Make an inside reverse fold on the existing creases.

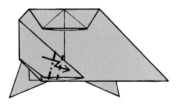

12 You have made a double reverse fold. Repeat steps 10–11 on the left flap. Turn the model over from side to side.

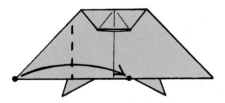

13 Fold the left corner to the raw edge as indicated.

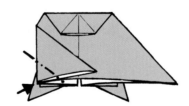

14 Make an inside reverse fold treating both layers as one.

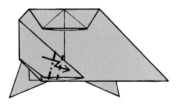

15 Make a pleat fold to form a hand so that the tip of the hand will rest to the left of the vertical crease.

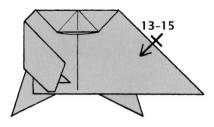

16 Repeat steps 13–15 on the right flap.

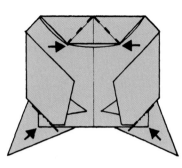

17 Make an inside reverse fold with each of the protruding lower flaps. Push the corners of the pocket toward each other forming a mouth.

18 Open the side pockets into teardrop shapes to form eyes. Fold each foot up making folds that line up with the bottom edge of the body. (Look ahead to step 20 to see the result.) Turn the model over from side to side.

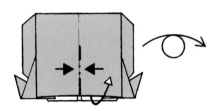

19 Pull the front layer toward you and slightly upward. Then pinch a mountain fold along a portion of the crease. Turn the model over from side to side.

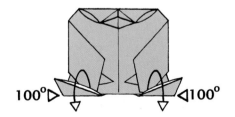

20 Open each indicated fold to an angle that is a little greater than 90°. Stand the completed model resting it on its back edge and the back edges of its feet.

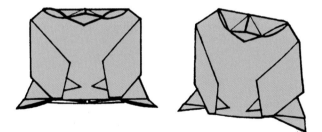

21 Make another Extraterrestrial. Position the arms and head a little differently and display both models together. You can make an interesting scene using this model and Crater (taught later in this chapter).

Reversible Star

Created by Marcia Joy Miller

Flip this decorative star over and you will discover a different design.

PAPER: Make the model from the designated sheet of folding paper included in the back of the book on page 143. You can also use a 6-inch square of origami paper or paper-backed foil. After you become familiar with the model, you can create Reversible Star from a 3-inch square of origami paper or paper-backed foil.

BASIC TECHNIQUES: A knowledge of how to make a valley fold and a mountain fold is all that is needed (see Chapter 1—Terms and Symbols).

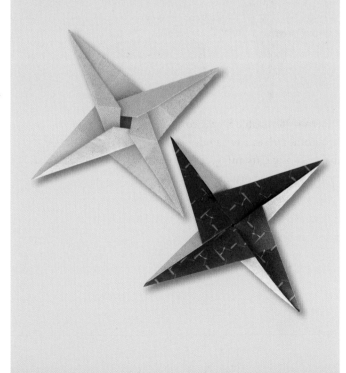

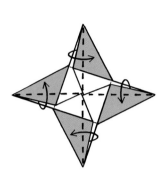

1 Start with a completed Pinwheel from Thirds by folding steps 1–19 of Blossom Blow-Top which appears later in this chapter. (If you are using the included folding paper, begin the Pinwheel from Thirds with the patterned-side facing you.) Position the model as shown. Then, on the right section, make the indicated fold on its front flap. Make similar folds with the other three sections.

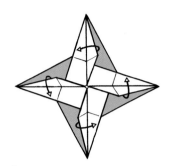

2 Open the folds that you made in the last step.

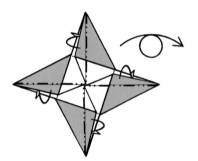

3 Tuck each of the four indicated flaps under itself. Next, turn the model over from side to side.

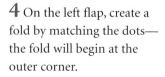

4 On the left flap, create a fold by matching the dots— the fold will begin at the outer corner.

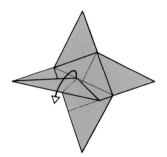

5 Open the fold that you made in the last step.

6 Make the indicated fold on the top section by matching the dots. (This fold is similar to the one that you made in step 4.) Unfold. Repeat the procedure with the right and bottom flaps.

7 Fold on the indicated existing crease.

8 Fold on the existing crease as shown.

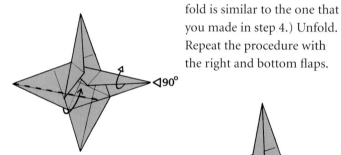

9 Fold on the existing crease as shown. Next, stand the indicated flap up at a right angle.

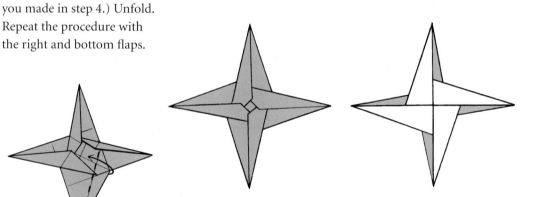

10 Fold on the indicated existing crease, including the small portion of the crease that is under the upright flap.

12 Your Reversible Star is complete. Now, turn the star over for another view. You can do a lot with this model—such as decorating gifts and greeting cards, making mobiles, and creating hanging ornaments.

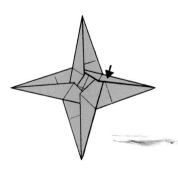

11 Flatten the upright flap and any other flaps that are standing.

Crater

Created by Marcia Joy Miller

Create scenes of moons or planets that include craters. You can also add Extraterrestrial to the scene.

PAPER: Create the model from the designated sheet of folding paper included in the back of the book on page 145. You can also use a 6-inch square of origami paper.

BASIC TECHNIQUES: See Chapter 1 for the Flower Base exercise.

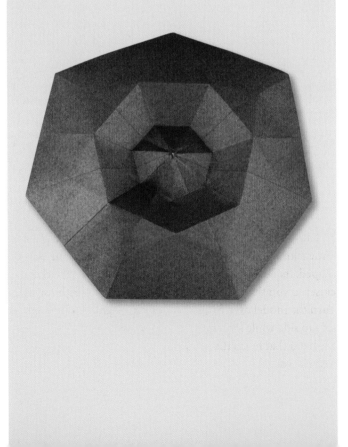

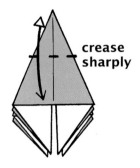

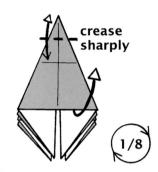

1 Start with a completed Flower Base. Bring the top corner to the edge making a very sharp fold. Unfold.

2 Bring the top corner to the crease making a very sharp fold. Unfold. Next, open the model completely. Rotate the model one-eighth turn clockwise.

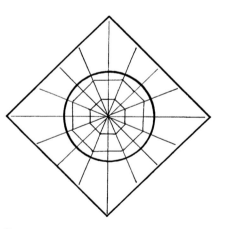

3 Steps 4–5 will show a magnified view of the circled portion, which includes two octagons.

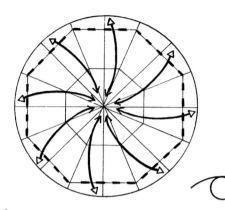

4 Make eight partial valley creases along the creases to emphasize the outer octagon. Turn the model over from side to side.

5 Make eight partial valley creases along the creases to emphasize the outer octagon. Turn the model over from side to side.

6 Make the indicated crease pattern. Rotate the model one-quarter turn clockwise.

 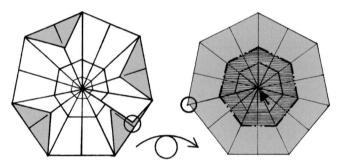

7 With each corner, make a fold that connects the creases.

8 Gently press the center point with a finger of your left hand as you make a pleat fold on the existing creases with your right hand. After making this pleat fold, hold it closed with your right hand.

9 The model is now three-dimensional and bowl-shaped. Its outside edges are closer to you than its center. Turn the model over from side to side while switching the hand that holds the pleat fold closed.

10 As you hold the pleat fold closed with your left hand, push on the darker-shaded section with fingers of your right hand causing it to recess.

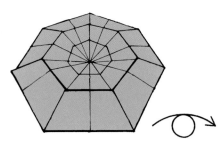

11 Turn the model over from side to side.

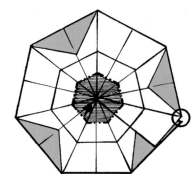

12 Hold the pleat fold closed with your right hand while you push on the darker-shaded section with fingers of your left hand causing it to recess.

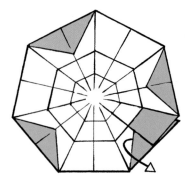

13 Pull out the flap.

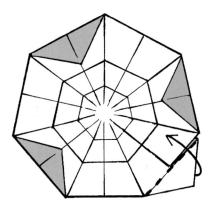

14 Fold the flap on the existing crease.

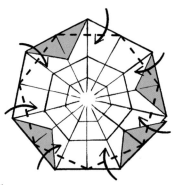

15 Make the seven folds as shown. (Notice that each fold will connect the midpoint of one edge to the midpoint of an adjacent edge.)

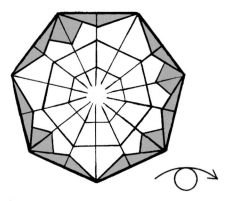

16 Turn the model over from side to side.

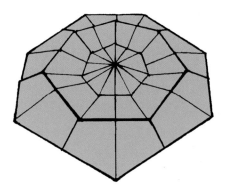

17 Your Crater is finished. To create a landscape of craters, fold several from the same color paper and display them on a sheet of paper of like color. To make an interesting landscape, vary the sizes of the squares used to fold the craters. Varying the shape of the craters is an additional way to create interest. Do this by positioning the creases formed in steps 1 and 2 a little closer to the top corner of the model.

Blossom Blow-Top

Created by Gay Merrill Gross

Blossom Blow-Top is a fun toy. Blow on this colorful flower and it spins.

PAPER: Make your first Blossom Blow-Top from either the designated 8-inch square of folding paper included in the back of the book on page 147 or a 6-inch square of origami paper. A model folded from a smaller square than these sizes will spin faster. So after you become familiar with the model, create the model from a 4-inch square using the designated folding paper included in the back of the book on page 149. (See the instructions under the subheading "Other Supplies" in Chapter 1 to learn how to make a 4-inch square from an 8-inch square.) You can also use a 3-inch square of origami paper or a square of memo cube paper.

BASIC TECHNIQUES: Knowledge of how to make a valley fold and a mountain fold is all that is needed (see Chapter 1—Terms and Symbols).

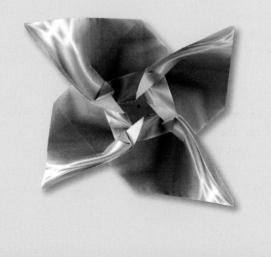

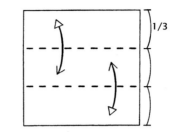

1 If you are using the included folding paper, start with the solid-color side facing you. If you are using origami paper, start with the white side facing you. Divide the square into thirds with valley creases. Steps 2–5 show how this procedure is done. The result is shown in step 6.

2 Bend the top edge of the square away from you and the bottom edge toward you so that when the model is viewed from the left side, its shape resembles that of a backward letter "s."

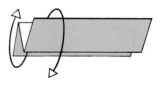

3 Press each bend into a fold, keeping each bend lined up with an edge. The top bend should line up with the top front edge of the model and the bottom bend with the bottom back edge of the model.

4 Observe that when viewed from its left side the shape of the model resembles that of the letter "z." Unfold the model completely to the white side.

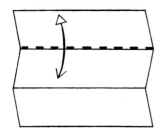

5 Observe that the top horizontal crease is a mountain crease. Change it into a valley crease.

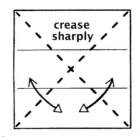

crease sharply

6 Crease both diagonals sharply. The sharp creases will help the finished model to spin better.

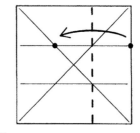

7 To divide into thirds in the other direction, fold the right edge to meet the intersection point of the indicated diagonal and top horizontal crease.

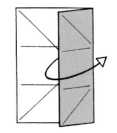

8 Open the fold.

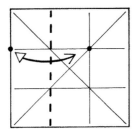

9 Fold the left edge to the vertical crease.

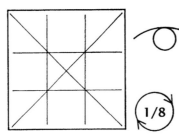

10 Rotate the model one-eighth turn clockwise. Turn the model over from side to side.

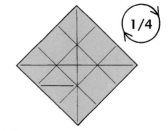

11 Bring the bottom corner to the intersection of creases that is located furthest away from it. Make a partial fold to the left of the center crease. Unfold.

12 This is the result of the last step. Rotate the model one-quarter turn clockwise.

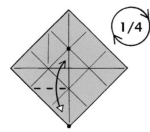

13 Make a partial fold. Unfold. Rotate the model one-quarter turn clockwise.

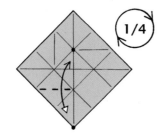

14 Make a partial fold. Unfold. Rotate the model one-quarter turn clockwise.

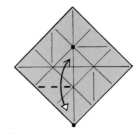

15 Make a partial fold. Unfold.

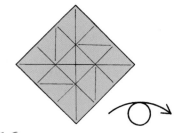

16 Turn the model over from side to side.

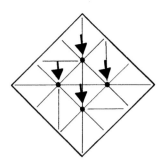

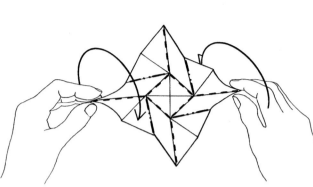

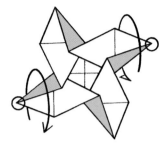

17 This step may be helpful to beginners. Observe each of the four locations indicated by a dot and check to see if any are raised. Depress each raised spot by pressing that point with your finger. This causes the model to take on a shape that will make the twist fold of the next step easier to do.

18 Make a twist fold. Steps 18–19 show how this procedure is done. The result is illustrated in step 20. Hold the model as illustrated, pinching the right and left side corners in half on the valley creases. Begin twisting your right hand away from you and your left hand toward you.

19 Continue twisting until the model closes flat.

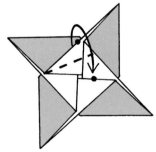

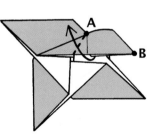

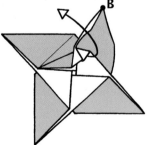

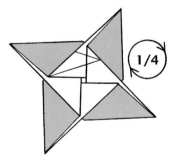

20 The form that you have made is commonly referred to as a "Pinwheel from Thirds." Now, bring the raw edge to the folded edge and make a partial fold as shown.

21 Fold the flap from the location that was the center point in step 20 to A.

22 Notice that B is now standing up and the flap is curved toward you. Unfold steps 20–21 and flatten your paper.

23 Rotate the model one-quarter turn clockwise.

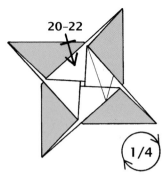

24 Repeat steps 20–22. Rotate the model one-quarter turn clockwise.

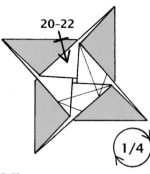

25 Repeat steps 20–22. Rotate the model one-quarter turn clockwise.

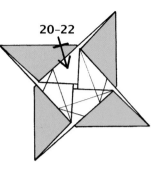

26 Repeat steps 20–22.

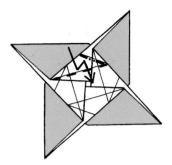

27 Refold on the existing creases causing the top right flap to rise and curve toward you.

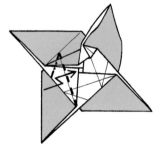

28 Refold on the existing creases causing the top left flap to rise and curve.

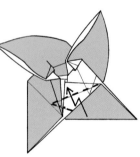

29 Refold on the existing creases causing the bottom left flap to rise and curve.

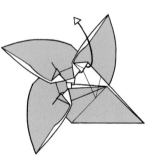

30 Partially unfold step 27 (the top right flap).

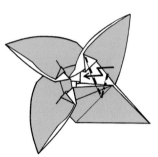

31 Refold on the existing creases. Observe that a part of the valley crease that you will be refolding on is tucked under the top right flap.

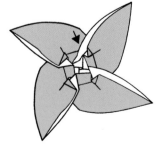

32 Push down on the top right flap, replacing the folds you partially unfolded in step 30.

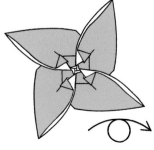

33 Turn the model over from side to side.

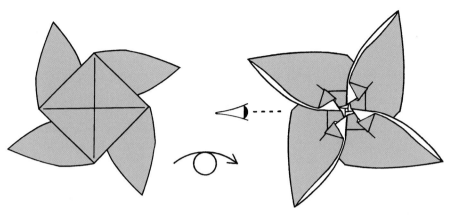

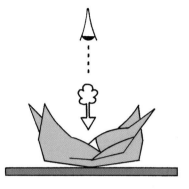

34 For better spinning, mold the center bottom square so that the center of the square is slightly higher than its sides. Look ahead to the drawing of step 36. It shows the slight curve on the bottom of the flower that you are trying to achieve. Turn the model over from side to side.

35 Make sure the "petals" are evenly formed and equally spaced. The next view will be from the side of the blossom.

36 Place the model on a smooth surface. Blow directly downward into the center of the model causing it to spin counterclockwise. The next view will be from the top of the blossom.

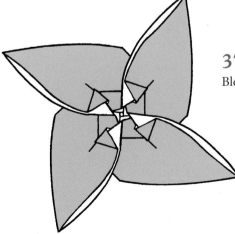

37 Have a great time with your Blossom Blow-Top. It makes a unique gift.

Gay Merrill Gross teaches workshops introducing origami through storytelling. She is the author of several books on origami and napkin folding. Her favorite origami models include useful designs and action toys.

Trophy Bowl
Created by Marcia Joy Miller

Trophy Bowl can be used as a candy dish or a presentation piece. The model is a modular design made from three units. You can create the modules during coffee breaks and connect them at lunchtime.

PAPER: Create the model from the three sheets of designated folding paper included in the back of the book starting on page 151. You can also, if you are planning to use Trophy Bowl as a candy dish, make it from three 8½-inch squares of medium weight bond paper in different colors. When the model is created from shiny paper-backed foil, the colors of its faces reflect and mix with each other giving a pretty effect. To make the model from foil, you will need three 6-inch squares of shiny medium weight paper-backed foil in different colors. Experienced folders can also create the model from other types of paper.

BASIC TECHNIQUES: See Chapter 1 for the Waterbomb Base exercise.

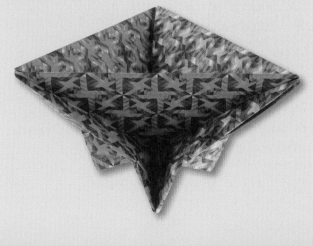

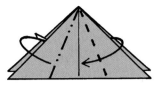

1 Start with a completed Waterbomb Base. (If you are using the included folding paper, begin the Waterbomb Base with the solid-color side facing you.) First, mountain fold the left front flap as indicated. Next, valley fold the right front flap as shown.

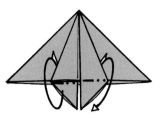

2 First, mountain fold and then unfold the bottom of the right front flap as shown. Next, mountain fold the bottom of the left front flap as indicated.

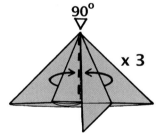

3 Stand the two front flaps at a right angle to the rest of the model. Make two more units from the remaining squares.

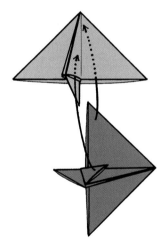

4 Position two units as shown. Insert the large top flap of the bottom unit into the large right flap of the top unit. Notice that on the right side of the upright flap of the top unit, there are two pockets. You will be using the rightmost of these pockets. Tuck the indicated tab of the bottom unit inside this pocket. Slide both units together as far as possible.

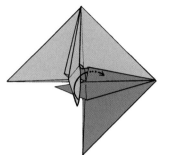

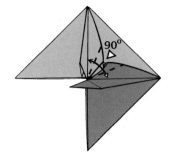

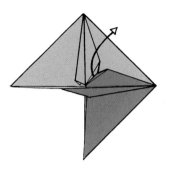

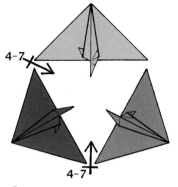

5 The bottom unit has an upright flap with two pockets. You will use the pocket that is closest to you. Tuck the indicated tab of the top unit into that pocket. Slide both units together as far as possible.

6 Steps 4 and 5 created two vertical "walls." Similar to making a rabbit ear fold, push the walls toward each other forming a new flap. Fold the new flap to the left, unfold, and then fold it to the right. Next, stand the flap up at a right angle.

7 Disconnect the two units.

8 Repeat steps 4–7 to connect and disconnect the two bottom units. Next, repeat steps 4–7 for the top and left units.

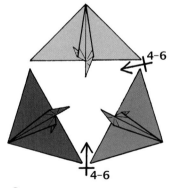

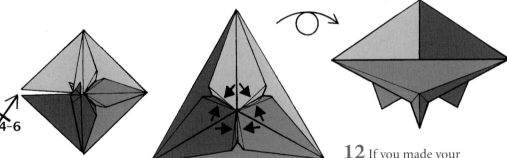

9 Repeat steps 4–6 for two connections.

10 Now, repeat steps 4–6 to make the last connection which will cause the model to become three-dimensional.

11 Pinch the sides of each of the three protruding flaps together to emphasize them. Turn the model over and place it on a table.

12 If you made your Trophy Bowl from bond paper, it is sturdy enough to hold wrapped candies.

Name-It Box

Created by Marcia Joy Miller

Name-It Box is handy for storing lightweight items or for gift giving. The lid has two areas on which you can describe the box's contents or write a greeting. You can create the lid during a lunch break and the bottom during another lunch break.

PAPER: Make the model from the two sheets of designated folding paper included in the back of the book on pages 157-160. You can also use two 10-inch squares of origami paper of the same color.

BASIC TECHNIQUES:
See Chapter 1 for the Squash Fold exercise.

SPECIAL INSTRUCTIONS: Make sharp folds.

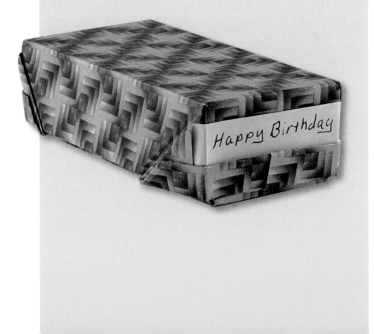

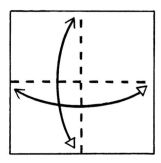

1 Box Bottom: If you are using the included folding paper, start with one of the squares of paper with the solid-color side facing you. If you are using origami paper, start with one of the squares of paper with the white side facing you. Fold the bottom edge to the top edge. Unfold. Fold the right edge to the left edge. Unfold.

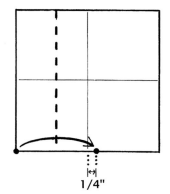

1/4"

2 Fold the left edge to the right so that it is positioned approximately ¼" to the right of the vertical center crease.

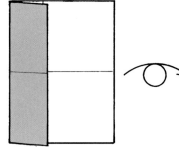

3 Turn the model over from side to side.

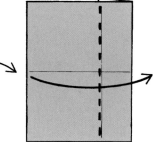

4 Fold the left edge to the right on the existing vertical crease.

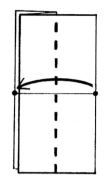

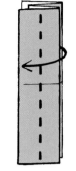

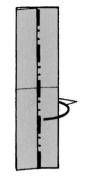

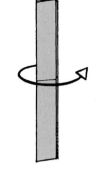

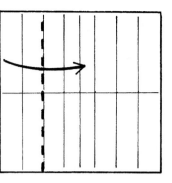

5 Fold the right edge over to meet the left edge.

6 Fold the front right edge over to meet the left edge.

7 Mountain fold the right edge to the left.

8 Unfold the model completely to the position shown in the next step.

9 Fold the left edge to the right along the second crease from the left.

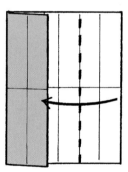

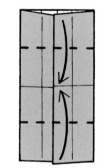

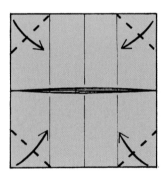

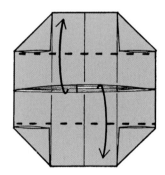

10 Fold the right edge to the left along the second crease from the right.

11 Fold the bottom edges to the horizontal crease. Fold the top edges to the horizontal crease.

12 Fold the bottom right corner up and to the left so that the edge meets the vertical crease. Make a similar fold on each of the other three corners.

13 In the center area there are two sets of raw edges. Fold the lower set downward so that the new fold rests against the top of the triangular flaps. Make a similar fold with the upper set of raw edges.

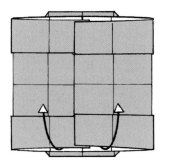

14 This step and the next one will show you how to make the squash fold on this flap. Lift the two front edges upward revealing a boat-shaped pocket. The model is now three-dimensional.

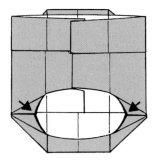

15 Squash each pocket flat by pressing down on the left and right sections.

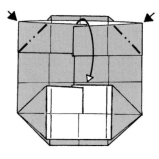

16 Completed squash fold. Check that the horizontal crease on each triangular section lines up with the folded edge on the white area. Make a squash fold with the upper flap similar to the one that you made in steps 14–15.

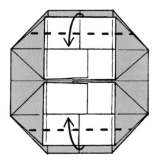

17 Fold the bottom raw edge of the lower flap to the folded edge. Fold the top raw edge of the upper flap to the folded edge.

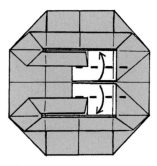

19 Fold the top edge of the lower section downward so that the new fold rests on top of the fold to the left of it and is lined up with it. Make a similar fold in the upper section.

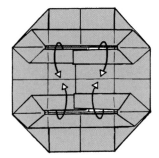

20 Open the four folds.

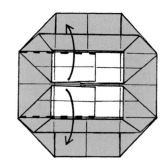

21 Fold the left flap in the lower section downward along the existing crease. Make a similar fold with the upper flap.

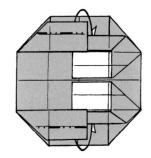

22 Tuck the edge of the upper front flap under the flap behind it. Tuck the edge of the lower front flap under the flap behind it.

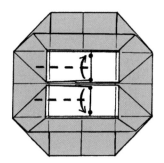

18 Fold the indicated edge of the upper section to a little below the folded edge. Fold the indicated edge of the lower section to a little above the folded edge.

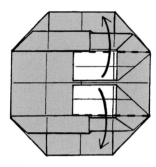

23 Fold the white flap in the lower section downward along the existing crease. Make a similar fold in the upper section.

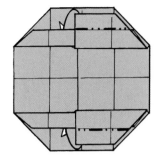

24 Tuck the edge of the upper front flap under the flap behind it. Tuck the edge of the lower front flap under the flap behind it.

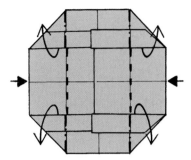

25 Place your thumbs under the top flap and push away from you causing the model to become three-dimensional. Do a similar procedure with the bottom flap. Push the sides towards the center causing the model to take on a box-like shape.

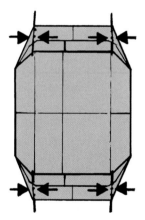

26 Refine the shape of the model into one of a box by pinching mountain folds along the outside corner edges.

27 The long sides of the box curve outward. To make them stand up, push in on each side. Position the model so that you are looking at the left side.

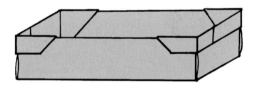

28 You have completed the bottom of the box. Now, you are ready to make the lid.

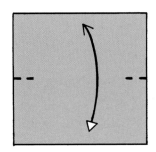

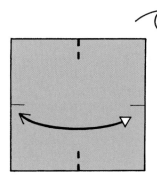

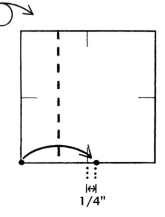

29 Lid: If you are using the included folding paper, start with the other square of paper with the solid-color side facing away from you. If you are using origami paper, start with the other square of paper with the white side facing away from you. Make two landmarks (short creases) by bringing the bottom edge to the top edge and making partial folds approximately 1" in length at the left and right sides—and then unfold.

30 Make two landmarks by bringing the right edge to the left edge and making partial folds approximately 1" in length at the top and bottom—and then unfold. Turn the model over from side to side.

31 Fold the left edge to the right so that it rests approximately ¼" to the right of the landmarks.

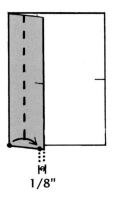

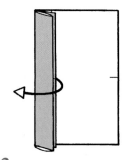

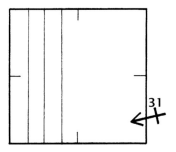

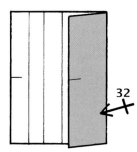

32 Fold the left edge to the right so that it rests approximately ¹/₈" to the left of the vertical edge. This increases the width of the finished lid.

33 Unfold completely.

34 Repeat step 31 with the right edge. (Hint: fold the right edge to the left so that it rests approximately ¼" to the left of the landmarks.)

35 Repeat step 32 with the right edge. (Hint: fold the right edge to the left so that it rests approximately ¹/₈" to the right of the vertical edge.)

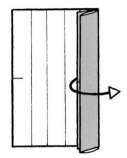

36 Open the model completely.

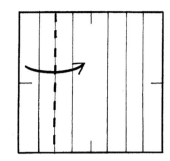

37 Fold the left edge to the right along the second crease from the left.

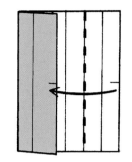

38 Fold the right edge to the left along the second crease from the right.

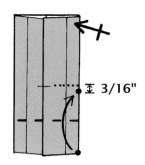

39 Fold the bottom edges up so that they rest approximately ³/₁₆" below the landmarks. Repeat the fold with the top edges so that they rest approximately ³/₁₆" above the landmarks. This increases the length of the finished lid.

⊥ 3/16"

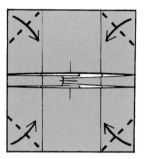

40 Fold the bottom right corner up and to the left so that the edge meets the vertical crease. Make a similar fold on each of the other three corners.

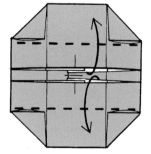

41 In the center area, there are two sets of raw edges. Fold the lower set downward so that the new fold rests on top of the triangular flaps. Make a similar fold with the upper set of edges.

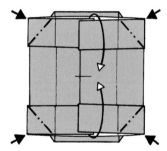

42 Make two squash folds with the top flap and then with the bottom flap. (Hint: see steps 14–15.)

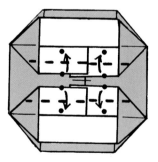

43 Fold the left flap of the upper section upward so that the edge rests a little below the fold. Make similar folds with the other three flaps as shown.

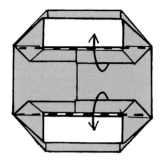

44 Fold the upper flaps upward. Fold the lower flaps downward.

45 Write on the "label" area to identify what the contents of the box will be. If the box will be used for gift giving, then write a greeting. Next, create a box-like shape in a manner similar to step 25. Rotate the model one-half turn clockwise.

46 Shape the box in a manner similar to steps 26–27. Turn the model over from side to side.

47 Place the top of the box over the bottom.

48 If you would like to fold the box from a heavier paper, slightly increase the measurements referred to in steps 32, 35, and 39 in order to make the lid longer and wider.

Organize your desk with the help of origami. (Parrot Page Clip is taught in Chapter 2 and Fluted Vase is taught in Chapter 4.)

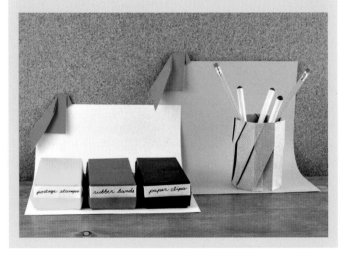

Jack-O'-Lantern

Created by Marcia Joy Miller

A convenient way to "carve" a pumpkin for Halloween is to fold one from paper. You can change the shape of Jack-O'-Lantern and its facial features by following the suggestions given at the end of the instructions.

PAPER: Make the model from the designated sheet of folding paper included in the back of the book on page 161. You can also use a 10-inch square of orange origami paper. After you become familiar with the model, you can fold it from a 6-inch square of origami paper.

BASIC TECHNIQUES: A knowledge of how to make a valley fold and a mountain fold is all that is needed (see Chapter 1—Terms and Symbols).

SPECIAL INSTRUCTIONS: If folding the model from a 6-inch square, make proportionate changes to the lengths specified in steps 2, 11, 14, and 15.

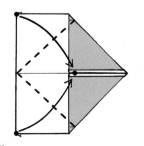

1 Start with the orange side of the paper facing away from you. Fold the right edge to the left edge. Unfold. Fold the top edge to the bottom edge.

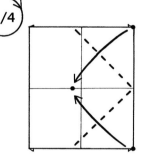

3/8"

2 Fold the front edge up making approximately a ¼" hem and then fold the hem over again. Next, repeat the procedure on the back flap.

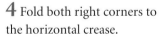

1/4

3 Open only the top fold. Rotate the model one-quarter turn clockwise so that the short edges are positioned at the top and the bottom.

4 Fold both right corners to the horizontal crease.

5 Fold both left corners to the horizontal crease.

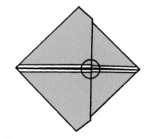

6 Steps 7–10 will show a magnified view of the circled area.

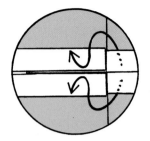

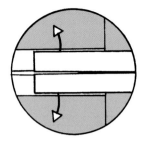

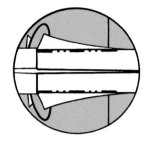

7 Lift both layers of the bottom right hem up and place them over the bottom left hem. Lift both layers of the top right hem up and place them over the top left hem.

8 Partially open the lower folded edge of the bottom right hem. Partially open the upper folded edge of the top right hem.

9 Tuck the layer of the bottom hem that you revealed in the last step under the double layer of the hem on its left. Perform a similar procedure with the top hem.

10 For both the top and bottom hems, the two layers of the hem on the left side should be enclosed within the two layers of the hem on the right.

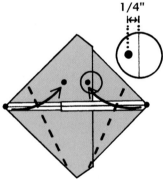

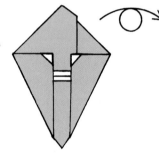

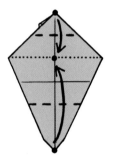

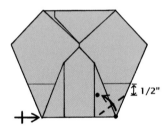

11 Fold the bottom right edge so that it rests approximately ¼" to the left of the raw edge. Fold the bottom left edge over so that the flap that is formed looks identical to the one on the right.

12 Turn the model over from side to side.

13 The dotted line represents an imaginary line that connects the two side corners. Fold the bottom corner up to the dotted line. Fold the top corner down to the dotted line.

14 If you are using the included folding paper, fold the bottom right corner up and to the left so that the upper edge of the new flap is located approximately $3/8$" below the crease and is parallel to it. (If you are using 10-inch origami paper, make this amount ½" as indicated by the illustration.) Repeat on the left side.

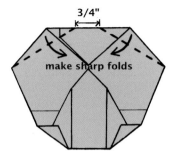

15 Sharply fold the top corners down so that the new folds are approximately ¾" apart at the top.

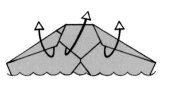

16 Steps 16–21 illustrate the top portion of the model. Unfold the three flaps at the top of the model.

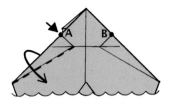

17 Notice that A is located at the intersection of the left edge and the shorter slanted crease. Push A down and to the right as you refold the model on the longer slanted crease. The model is now three-dimensional.

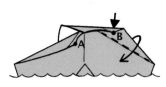

18 Similar to the last step, push B down and to the left as you refold the model on the long slanted crease.

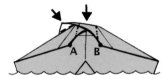

19 Hold A in place with your right index finger and B in place with your right middle finger. Notice that the top flap is formed into a hood shape and that there is a flap to the left of the hood that stands away from it. Smooth that flap so that it conforms to the shape and rests on top of the hood. Next, squash the hood flat.

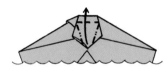

20 Fold the center flap upward. Layers beneath this flap will pull upward and curl inward. Narrow flaps will form on each side of the stem. Press all the folds flat.

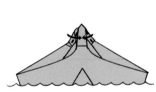

21 The top flap will be the stem of the pumpkin. Slim the stem with two valley folds. Flatten the area.

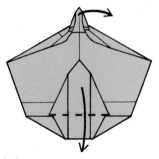

22 Pull the stem to the right a bit to angle it (or pull it to the left, if that is easier to do) and then flatten the area. Fold the flap near the bottom downward so that the new fold rests on the top edge of the bottom flaps.

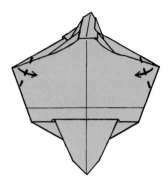 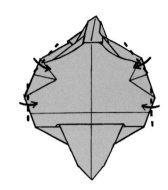 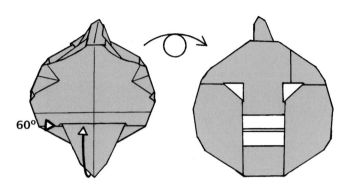

23 Fold the right corner down and to the left. Fold the left corner down and to the right.

24 Blunt the four corners by making a tiny valley fold with each.

25 Open the fold to a 60° angle. Turn the model over from side to side. Stand the model.

26 Display your Jack-O'-Lantern. If you would like to use it as a flat decoration, do not fold the bottom flap down in step 22. You can paste the flat version onto a greeting card or use it as a window decoration.

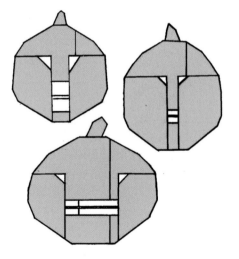

27 For added fun, you can individualize the facial features and the shape of the pumpkin by making small changes to the folds. To change the eyes and the mouth, vary the amount of paper folded over and over in step 2. In step 11, change how far you fold over the flaps. This will affect the width of the mouth, the distance between the eyes, and the overall shape of the pumpkin. Vary the distance between the folds in step 13 to change the shape of the face. The amount that the bottom flap is folded should be changed only very slightly at first because it may effect how well the model stands. Take the same care in modifying step 14 which may also be used to change the pumpkin's shape. You can also modify its shape by varying steps 15, 23, and 24.

Morph Ball

Created by Marcia Joy Miller

Morph Ball is an attractive display piece and a fun toy that can easily be transformed into an eight-sided object and then "morphed" back into a ball. The model is a three-dimensional modular design made from two types of units. You can create the units during coffee breaks and connect them at lunchtime.

PAPER: Use twelve 5½-inch squares of medium weight bond paper. Choose three colors, four squares of each color.

BASIC TECHNIQUES: See Chapter 1 for the Squash Fold, Preliminary Base, and Sink Fold exercises.

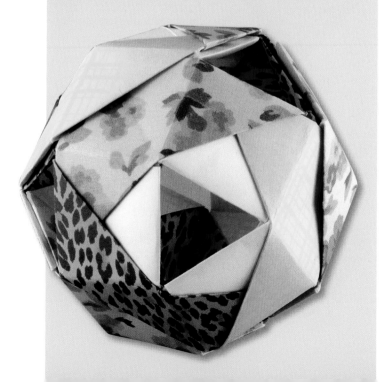

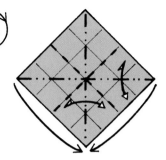

1 Tab Unit: Fold the bottom edge to the top edge and unfold. Fold the right edge to the left edge and unfold. Fold the top edge to the center horizontal crease and unfold. Fold the bottom edge to the center horizontal crease and unfold. Fold each side edge to the center vertical crease and unfold. Next, rotate the model one-eighth turn clockwise.

2 Mountain fold the bottom corner to the top corner and unfold. Mountain fold the right corner to the left corner and unfold. Create a Preliminary Base by bringing the side corners to the bottom corner and flattening the model.

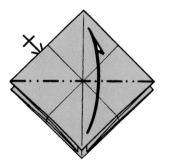

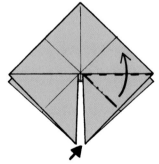

3 Mountain fold the bottom of the flap into the model. Repeat behind.

4 Squash fold the bottom right flap.

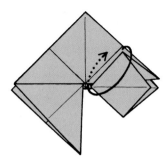

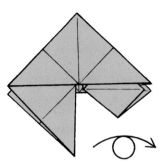

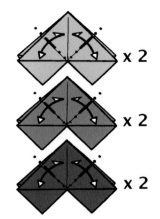

5 Tuck the top of the double layer under the triangular flap.

6 Turn the model over from side to side.

7 Repeat steps 4–5 on the right flap.

8 Completed tab unit. Create an additional tab unit in the same color and two tab units from each of the two remaining colors. Next, with each unit, make the indicated mountain creases through all layers on the existing creases.

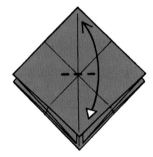

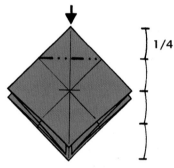

9 Pocket unit: Start by completing steps 1–2. Then, make a short crease on the front as shown.

10 Sink fold the top quarter of the model.

11 Fold the bottom corner of the front flap up as shown.

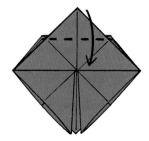

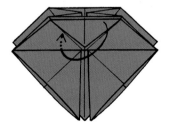

12 Fold the top corner to the folded edge.

13 Tuck the double layer inside.

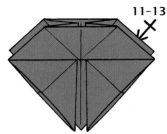

14 Repeat steps 11–13 on the back.

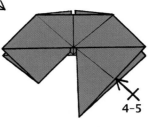

15 Repeat steps 4–5. Turn the model over from side to side.

16 Repeat steps 4–5.

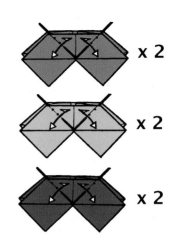

17 Completed pocket unit. Create an additional pocket unit from the same color and two pocket units from each of the two remaining colors. Then, with each unit, make the indicated mountain creases through all layers.

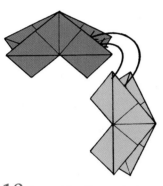

18 Assembly: Steps 18–24 show how to connect the ends of two units to build the rings shown in steps 26 and 28. Place the right unit between the layers of the top unit.

19 Steps 20–21 show a magnified view of the circled area.

20 Notice that B identifies the right corner of the diamond-shaped flap that is underneath the front layer of the left unit. Insert B into the pocket that is near A.

21 Slide the two units toward each other as far as possible.

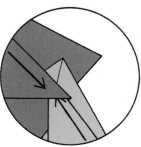

22 Turn the model over from side to side.

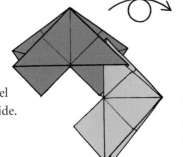

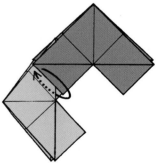

23 Tuck the flap of the top unit into the pocket of the left unit.

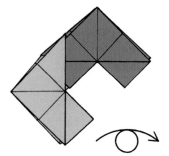

24 Turn the model over from side to side.

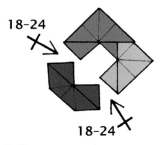

25 Connect the units by repeating steps 18–24. (Tip: before making the last connection, temporarily pull the units of an adjacent connection a little apart.)

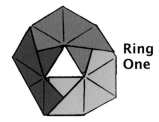

Ring One

26 You have completed the first of four rings. This ring will be referred to as Ring One.

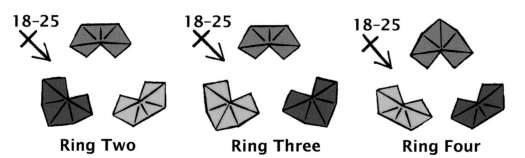

Ring Two Ring Three Ring Four

27 Arrange the remaining pocket and tab units as shown. Connect the units by repeating steps 18–25 for each ring.

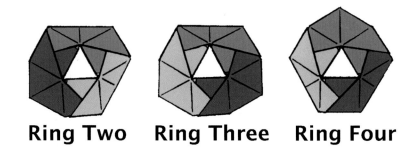

Ring Two Ring Three Ring Four

28 The illustration shows the three rings that you completed in the last step.

Ring One Ring Three

29 Position Ring One and Ring Three as shown. Connect them by placing each of the inner layers of the pocket between the layers of the tab. Next, slide the tab into the pocket as far as possible.

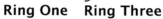

30 Position Ring Two as shown. Connect it to Ring One and to Ring Three by repeating step 29 for each of the two connections.

31 Turn the model over from side to side.

32 For the sake of clarity, only the sections of the assembled rings that are facing you are illustrated. Connect Ring Four to the other rings by repeating step 29 for each connection.

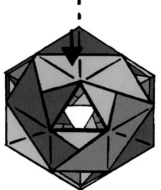

33 Your Morph Ball is now complete and ready to spin or roll. Morph it into a disc shape by gently pressing the top. The next view of the model will be from above.

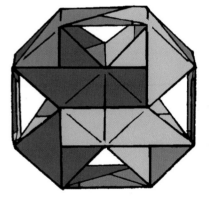

34 The disc shape also rolls. You can morph it back into a ball by cupping the disc in your hands and forming it into a ball.

Morph Ball may also be folded from 6-inch squares of scrapbook paper. It will not morph as smoothly as it does when made from medium weight bond paper. You may find, however, that you appreciate its elegant look and enjoy it as a display piece. Note: when folding this model from scrapbook paper, start with the white side facing you.

Carnival Spinner

Created by Marcia Joy Miller

Watching this brightly-colored top spin around and around may bring back memories of a fun-filled day at an amusement park. Carnival Spinner is a modular design made up of seven units. You can create the units during coffee breaks and connect them at lunchtime.

PAPER: Create the model from the seven sheets of designated folding paper included in the back of the book starting on page 165. You can also use seven squares of 6-inch origami paper in assorted colors.

BASIC TECHNIQUES: See Chapter 1 for the Waterbomb Base exercise.

SPECIAL INSTRUCTIONS: If you are folding the model from the included folding paper, in order to achieve the color wheel effect it is necessary that you fold and connect the units in the following sequence determined by the color of the solid-color side of each paper: yellow, yellow-green, grass green, blue, purple, red, and orange.

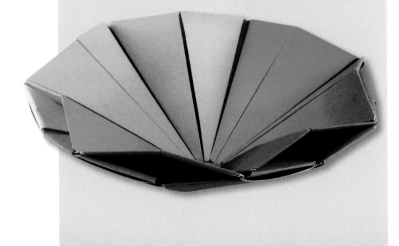

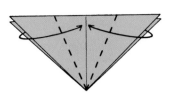

1 Start with a completed Waterbomb Base. (If you are using the included folding paper, begin the Waterbomb Base with the solid-color side facing you.) Turn the model over from top to bottom so that it is in the position shown in the next step.

2 Fold the right edge of the front flap to the crease. Fold the left edge of the front flap to the crease.

3 Turn the model over from side to side so that it is in the position shown in the next step.

4 Fold each top flap down against the raw edges.

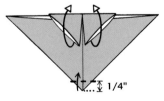

1/4"

5 Open the two folds at the top. Fold the bottom corner up ¼". (Tip: If you peek ahead in the diagrams, you will discover that you will be making all seven units exactly the same. It is a good idea to perform the procedure that you have just completed on all seven units before going ahead. Match each of the units to the first unit to ensure that you are folding the bottom tip up by the same amount.)

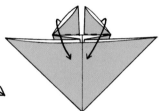

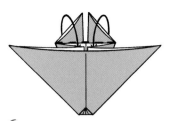

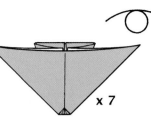

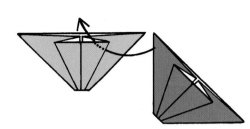

6 Tuck the right flap behind the third layer. Tuck the left flap in a similar manner.

7 Complete six more units. Turn each of the seven units over from side to side.

8 Select two units that are different colors. The right unit should be positioned so that one of its long folded edges is on the left. Place the left edge of the right unit in between the layers of the left unit.

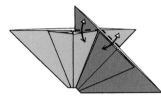

9 Sharply fold the right corner of the left unit against the edges of the right unit. Unfold. Sharply fold the top corner of the right unit down against the edges of the left unit. Unfold.

10 Using the existing crease, tuck the top corner of the right unit behind the front edge of the left unit. Using the existing crease, tuck the right corner of the left unit behind the front edge of the right unit.

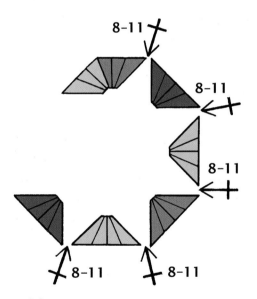

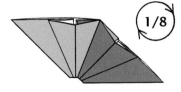

11 Prepare for the connection of the next unit by changing the position of the model so that the right unit will be positioned with its raw edges on top (as shown in the next step).

12 Repeat steps 8–11 five times to connect five additional units.

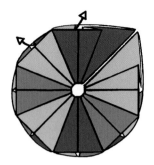

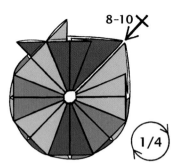

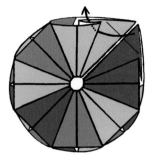

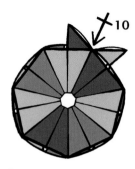

13 Disconnect the last unit by unlocking the two flaps. (Note: the reason for doing this is to keep the model flat so that the creases for the final connection may be made more easily and accurately.)

14 Repeat steps 8–10 connecting the recently disconnected unit to the unit on its right. Rotate the model one-quarter turn clockwise to the position shown in the next step.

15 Slide the left edge of the right unit in between the layers of the left unit. This will cause the model to take on a concave shape. When you look at the model, its shape will resemble that of a bowl.

16 Lock the two units together by repeating step 10. Check the model to make sure that all of the units appear to be connected properly. (It is helpful to look underneath the model as well.) Then, place the model on a table.

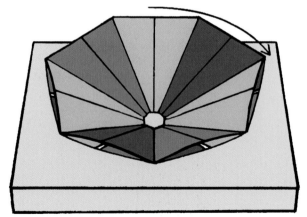

17 Your Carnival Spinner is finished and ready for action. Spin the model (either in a clockwise or counter-clockwise direction) using your hand to put it into motion.

After-Work Origami

This chapter includes beautiful display models that can be given away as endearing gifts. The flowers and foliage can be folded during short breaks of time. Then when you have a little more time to yourself, such as after work, you can create pretty floral arrangements. You will also make a charming vase that you can fold in the evening and use to display your floral arrangements. For a change of pace, you will also make an intricate geometric design that is modular. Its individual modules can be completed during coffee breaks. Later on, the entire model can be assembled after work.

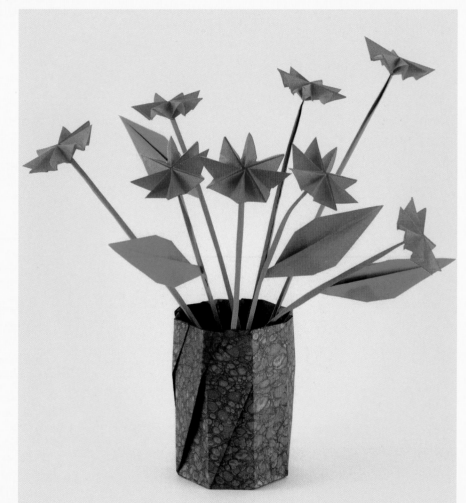

Fluted Vase

Created by Marcia Joy Miller

Display your origami flowers in elegant style with Fluted Vase. You can also use the vase as a handy pencil holder. This model is a little more challenging than the other intermediate-level models. So, make a few of the other intermediate models before working on this one.

PAPER: Make the model from the designated sheet of folding paper included in the back of the book on page 179. You can also use a square of bond paper that is from 8½ to 11 inches in size. After you gain experience folding the model, you will be able to create an especially attractive vase from a larger square of paper that has the thickness of heavy weight bond (such as art paper). If you do, then choose paper that is the same color or pattern on both sides. To make a pencil holder, fold the model from a square of medium weight bond paper that is from 8 to 10 inches in size.

BASIC TECHNIQUES: See Chapter 1 for the Flower Base exercise.

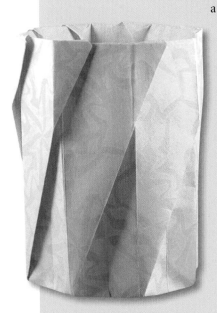

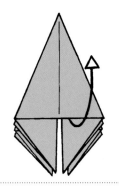

1 Start with a completed Flower Base. Open the model completely to its inside face.

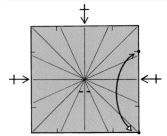

2 Bring the bottom edge to the horizontal center crease and make a short partial fold at each side edge. Unfold. Repeat with the other three edges.

3 Make the indicated partial crease. Repeat three times as shown.

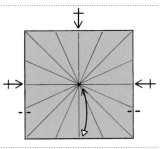

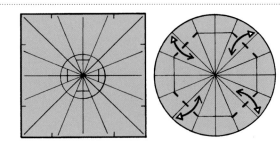

4 See the magnification circle for detail. Form an octagon by making partial creases that connect the existing partial creases.

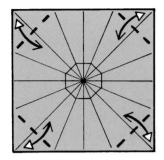

5 Make the four valley creases as shown.

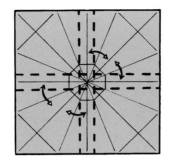

6 Make the four valley creases as indicated. (Notice that each new crease will intersect two corners of the octagon and will be parallel to an edge of the paper.)

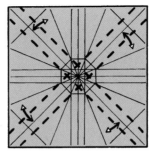

7 Make the four valley creases as shown. (Notice that each new crease will intersect two corners of the octagon and will be parallel to a diagonal crease.) Rotate the model one-eighth turn clockwise.

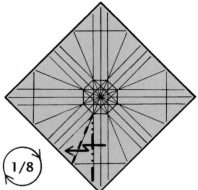

8 Make the indicated pleat fold. The model is now three-dimensional. (Tip: before making the pleat fold, make a mountain crease on the section of the line indicated for a mountain fold.)

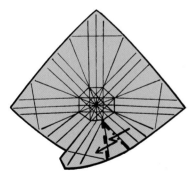

9 Make the indicated pleat fold. (Tip: before making the pleat fold, pinch a mountain crease on the section of the line indicated for a mountain fold.)

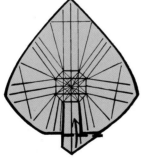

10 Make a fold on the existing crease.

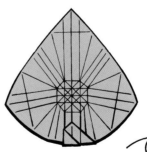

11 Turn the model over from side to side.

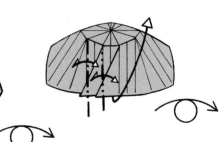

12 Pinch two mountain creases. Unfold the model. Turn the model over from side to side.

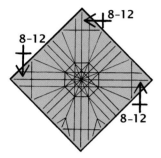

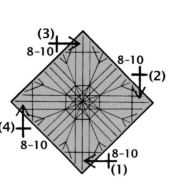

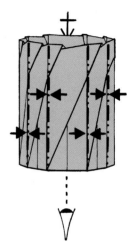

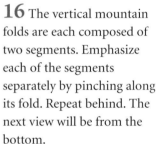

13 Repeat steps 8–12 on the other three sections.

14 Repeat steps 8–10 on each of the four sections in counter-clockwise order (as shown by the sequence numbers).

15 You are now looking into the vase. Tuck each of the four flaps into its adjacent pocket. Rotate the model to the view illustrated in the next step.

16 The vertical mountain folds are each composed of two segments. Emphasize each of the segments separately by pinching along its fold. Repeat behind. The next view will be from the bottom.

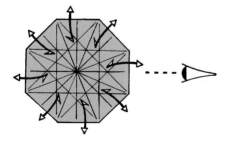

17 Emphasize each mountain fold by pinching along it, which will cause each to curve gently inward. This will also cause the center area to recede from you. Don't overdo this process. The next view is from the side of the vase.

18 Some flaps at the top may have popped out of their respective pockets. Tuck them in again as you did in step 15. Fill your Fluted Vase with a bouquet of origami flowers (see Spring Flower next in this chapter). For stability, you can place a coin or two inside the vase.

Spring Flower

Created by Marcia Joy Miller

Bring the beauty of a garden indoors by folding a bouquet of cheery blooms. You can make Spring Flower during lunchtime and then use it for floral display items that you create after work.

PAPER: Make your first Spring Flower from either the designated 8-inch square of folding paper included in the back of the book on page 181 or a 5½-inch square of bond paper. You can fold the stem from a 1½-inch rectangular strip of paper obtained by cutting on the dotted lines of the designated folding paper included in the back of the book on page 187. You can also use a 1½-inch strip of green medium weight bond paper. After you are comfortable folding the model, you can create the flower from a 4-inch square using the designated folding paper included in the back of the book on page 185. (See the instructions under the subheading "Other Supplies" in Chapter 1 to learn how to make a 4-inch square from an 8-inch square.) You can also fold the flower from a 3½-inch square of bond paper or memo cube paper and fold the stem from a strip of green medium weight bond paper that is 1-inch wide.

BASIC TECHNIQUES: See Chapter 1 for the Waterbomb Base and Sink Fold exercises.

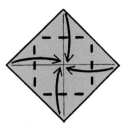

1 Fold the right corner to the left corner. Unfold. Fold the bottom corner to the top corner. Unfold.

2 Fold each corner to the center.

3 You have made what is commonly referred to as a "blintz fold." Turn the model over from side to side.

4 Make the crease pattern for a Waterbomb Base.

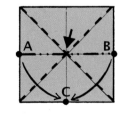

5 Depress the center point. Bring A and B to C.

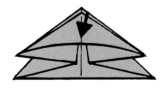

6 Flatten the model.

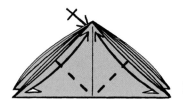

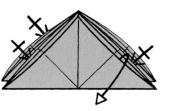

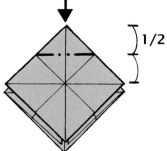

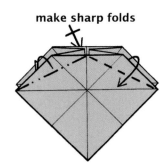

7 Notice that the flaps created by the blintz fold are on the outside of the model. The form that you have made is known as a "Blintz-Waterbomb Base." On the right front flap, make a valley crease and then mountain crease it on the same fold line. On the left front flap, make both a valley crease and a mountain crease on the same fold line. Repeat on the back.

8 Bring the front flap down. Repeat with the back flap and each side flap.

9 Sink fold the top corner making the fold one-half the distance from the top corner to the horizontal crease.

10 Sharply fold the front upper right corner down as indicated. Sharply fold the front upper left corner away from you as indicated. Turn the model over to repeat the sharp folds on the back.

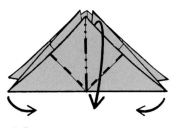

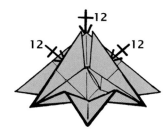

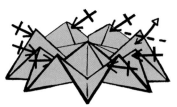

12 Bring the corner toward you pinching it so that a mountain fold forms on the center crease. As you do this, the two side corners will move toward you a little and two valley folds will form on existing creases.

13 Repeat step 12 on the other three flaps.

14 Make a small fold on the peak as shown and then unfold. Repeat on the other seven peaks. (Note: you will fold each peak so that it "points" in a clockwise direction before unfolding it.)

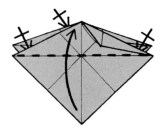

11 Fold the front flap up. Repeat on the other three flaps.

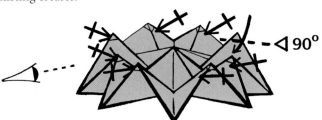

15 Arrange the eight petals so they are an equal distance from each other. Partially close the little folds that you folded and opened in the last step. Repeat with the other seven flaps. Position the model so that one of the four long flaps (that radiates from the center) points toward you.

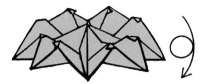

16 Notice how each little flap is "pointing" in the same direction—clockwise. Turn the model over from top to bottom. See step 20 for this view.

17 Paper Stem: If you are using the included folding paper, start with the solid-color side facing you. Fold the right edge to the left edge. Unfold. Next, fold the side edges toward the center crease so that they almost touch it.

18 Fold the side edges toward the center crease so that they almost touch it.

19 Fold the right edge to the left edge.

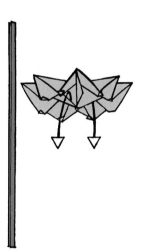

20 Completed stem. Open two of the long folds that are underneath the flower and opposite each other.

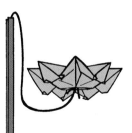

21 Insert the stem into the center of the opening as far as possible.

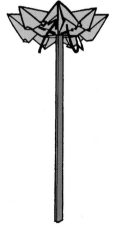

22 Close the two folds. Arrange the petals so that they are equally spaced. Also, partially close any of the little folds that have opened.

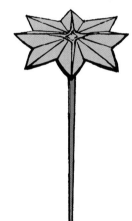

23 Create a bouquet of spring flowers and display them in a vase.

Foliage

Created by Marcia Joy Miller

Adding Foliage transforms a flower into a plant. It can also be used in a vase or a scene. At the end of the instructions, floral display ideas are shown that include Spring Flower and Fluted Vase (both models are taught in this chapter). You can create the components of Foliage during coffee breaks and then connect them during another coffee break.

PAPER: Fold the two leaf components from two 4-inch squares created from the designated folding paper included in the back of the book on page 189. (See the instructions under the subheading "Other Supplies" in Chapter 1 to learn how to make a 4-inch square from an 8-inch square.) Fold the stem from a 1½-inch rectangular strip of paper obtained by cutting on the dotted lines of the designated folding paper included in the back of the book on page 191. This included folding paper has optional dotted lines that you can cut along to shorten the strip for the stem. You can also create the model from bond paper. Use two 3½-inch squares of bond paper for the leaf components and a 1½ by 5½-inch strip of green medium weight bond paper for the stem component. For use in a vase, fold the stem from a longer strip of paper.

BASIC TECHNIQUES: See Chapter 1 for the Diamond Base exercise.

SPECIAL INSTRUCTIONS: Make sharp folds.

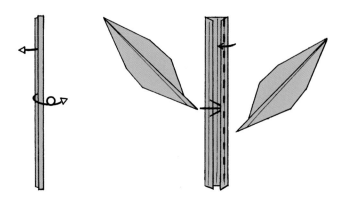

1 Start with a stem folded from a strip of paper (as shown by steps 17–19 of Spring Flower). Next, unfold the right side of the stem twice and the left side once.

2 Fold a left-hand version and a right-hand version of Oval Leaf from the squares (see Chapter 2). Insert the bottom of the left-hand leaf under the right flap of the stem as far as possible. Next, hold the leaf steady as you fold on the right vertical crease.

3 In a similar fashion to step 1, insert the right-hand leaf somewhat below the first leaf and under the left flap. Next, fold on the left vertical crease re-closing the flap so it rests underneath the left leaf.

4 Fold the right side of the stem to the left side.

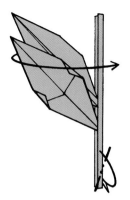

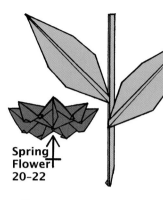

Spring Flower 20–22

5 Fold the bottom leaf to the right. If you will be using Styrofoam to support Foliage, then make the mountain fold as indicated.

6 Foliage can connect to an origami flower that has an opening in the back. To use it with Spring Flower, follow steps 20–22 of the instructions for Spring Flower.

7 The illustration shows the result of step 6. This may be "planted" in a flower pot or vase that contains a piece of Styrofoam or included in an origami scene that has a Styrofoam base.

FLORAL DISPLAY IDEAS

One bonus of creating flowers and vases from paper is showing them off. Foliage makes them especially attractive. Some ideas are discussed below:

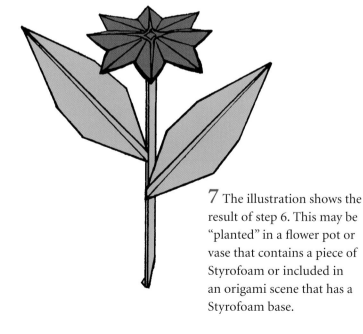

Create a delightful hostess gift using Foliage, Spring Flower, and a small flower pot. Styrofoam can be used to support the plant. Cover the Styrofoam with gravel for a finished look.

Use Foliage to enhance floral arrangements. If you like, you can include only the left-hand leaf. In that case, do not open the left side of the stem in step 1 and skip step 3. For variety, you can make a version with just a right-hand leaf. In the floral arrangement shown in the photograph, the leaves were made from 3-inch squares of bond paper. Fluted Vase was folded from a 13½-inch square of drawing paper.

Starry Sky

Created by Marcia Joy Miller

What a special feeling it is to gaze upon an evening sky. Recreate that experience by making Starry Sky. This model is a modular design that may be displayed on a wall. It is constructed from two types of units. You can create the modules during coffee breaks and connect them after work.

PAPER: Use thirty-six squares of medium weight bond paper that are all the same size. Choose twenty-four squares in a sky color and twelve squares in a star color. A convenient paper from which to fold Starry Sky is 3½-inch memo cube paper.

BASIC TECHNIQUES: See Chapter 1 for the Squash Fold, Preliminary Base, and Sink Fold exercises.

1 Tab unit: Start with a completed Preliminary Base made from star-color paper. Mountain fold the bottom of the flap into the model. Repeat behind.

2 Squash fold the right flap.

3 Tuck the top of the double layer under the triangular flap.

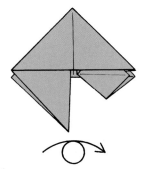

4 Turn the model over from side to side.

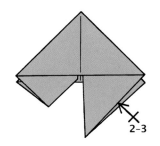

5 Repeat steps 2–3 on the right flap.

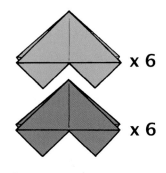

x 6

x 6

6 Completed tab unit. Make five more from star-color paper and six from sky-color paper.

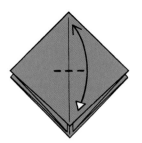

7 Pocket unit: Start with a completed Preliminary Base made from sky-color paper. Make a short crease on the front.

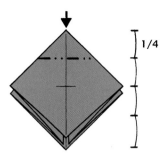

8 Sink fold the top quarter of the model.

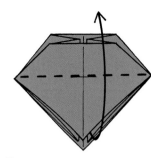

9 Fold the flap up.

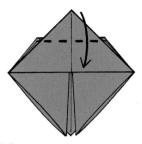

10 Fold the top corner to the folded edge.

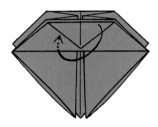

11 Tuck the double layer inside.

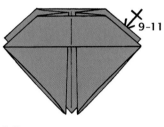

12 Repeat steps 9–11 on the back.

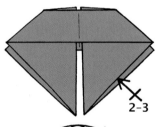

13 Repeat steps 2–3. Turn the model over from side to side.

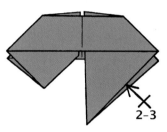

14 Repeat steps 2–3.

15 Completed pocket unit. Make seventeen additional pocket units in sky-color and six pocket units in star-color.

x 18

x 6

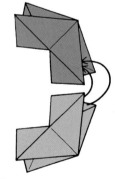

16 Assembly: Steps 16–22 show how to connect the ends of two units to build the motifs shown in step 24. Place the bottom unit between the layers of the top unit.

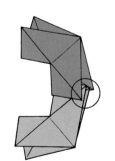

17 Steps 18–19 show a magnified view of the circled area.

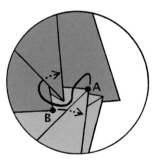

18 Notice that B identifies the bottom right corner of the square flap that is underneath the front layer of the top unit. Insert B into the pocket that is near A.

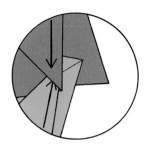

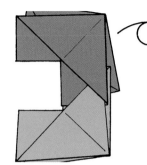

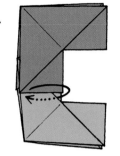

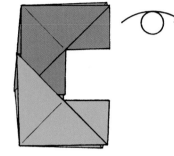

19 Slide the two units toward each other as far as possible.

20 Turn the model over from side to side.

21 Tuck the flap of the top unit under the flap of the bottom unit.

22 Turn the model over from side to side.

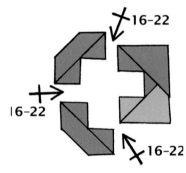

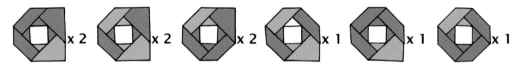

23 Connect the units by repeating steps 16–22. (Tip: before making the last connection, temporarily pull the units of the opposite connection a little apart.)

24 You have finished one motif. Now, complete the indicated numbers of motifs, by type, using the sky and star colors as shown. Notice that some motifs are made using only one tab unit and there is one motif made from only pocket units. This will give the outside edge of the completed model a uniform look.

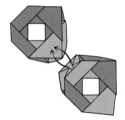

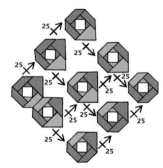

25 This step shows how to connect motifs by using the pocket and tab feature. Place each of the inner layers of the pocket between the layers of the tab. Slide the tab into the pocket as far as possible.

26 Position the motifs as shown and connect them by repeating step 25.

27 Congratulations! Your Starry Sky is ready for display.